Some Cities

Some Cities
Victor Burgin

University of California Press
Berkeley Los Angeles

University of California Press
Berkeley and Los Angeles, California

Published in the USA and Canada by arrangement with
Reaktion Books Ltd, London

Burgin, Victor
 Some cities / Victor Burgin.
 p. cm.
 ISBN 0-520-20636-3 (pbk.)
 1. Great Britain—Social life and customs—20th century—
Pictorial works. 2. City and town life—Great Britain—
Pictorial works. 3. Cities and towns—Great Britain—
Pictorial works. I. Title
 DA566.4.B795 1996
 941—dc20 95-50336
 CIP

Printed and bound in Great Britain
by BAS Printers, Over Wallop, Hampshire

9 8 7 6 5 4 3 2 1

Funded by
THE
ARTS
COUNCIL
OF ENGLAND

SOME CITIES

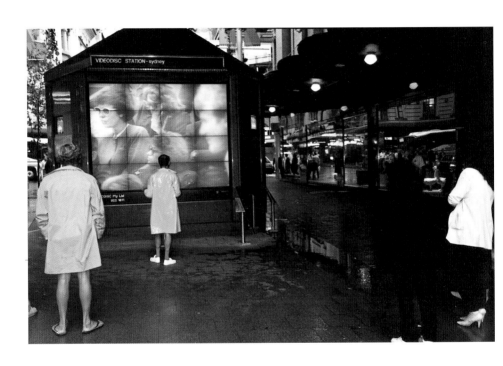

OUR RELATIONS WITH CITIES ARE LIKE OUR RELATIONS WITH PEOPLE. We love them, hate them, or are indifferent toward them. On our first day in a city that is new to us, we go looking for the city. We go down this street, around that corner. We are aware of the faces of passers-by. But the city eludes us, and we become uncertain whether we are looking for a city, or for a person.

We cannot know a 'city', only those of its places we come to frequent. Aspects of a city may be revealed to us only as we leave it forever, just as people who have been intimates for many years may glimpse certain aspects of each other only in the moment they part. Remembering the cities we have left, we recall only certain times spent in certain places. Places we almost never think of when we are awake may repeatedly return in our dreams. The most persistent of these are places we did not choose – those of our childhood.

As adults, we have our own reasons for being in one city rather than another. Michel Leiris anguished: 'To be, or not to be. That is not the question which bothers me. To be, or not to be there. To be here, or to be elsewhere. That is the burning question so far as I am concerned.' For most of us, work settles the question. Part of my own work has been in response to invitations to make visual art works in and about cities. One recent invitation stated that the purpose of the commission was to have the invited artist 'leave a trace' in the city. This is not a book of such traces, a pocket edition of the works I have made. On occasions I describe a commission, to indicate what circumstances provoked the otherwise desultory displacements registered here. But my aim is less to record traces I have left in some cities than it is to recall some traces some cities have left in me.

Cities new to us are full of promise. Unlike promises we make to each other, the promise of the city can never be broken. But like the promise we hold for each other, neither can it be fulfilled.

7

It was dark before we reached Sheffield; so that we saw the iron furnaces in all the horrible splendour of their everlasting blaze. Nothing can be conceived more grand or more terrific than the yellow waves of fire that incessantly issue from the top of these furnaces ...This Sheffield, and the land all about it, is one bed of iron and coal. They call it black Sheffield, and black enough it is...

William Cobbett, *Northern Tour*, 31 January 1830

Made in Sheffield. Nights lit by the blaze of furnaces. The thud of steam-hammers echoing down canyons of huge steel hangers. Acrid air. The furthest back I remember is being woken by my mother in the middle of the night. We sat at the bottom of the stairs, in the narrow hall between the kitchen and the downstairs room. The front door was opposite us. A pane of glass set high in the door showed a rectangle of pale night sky. As I watched this floating blank page it abruptly displayed a black cross, trailing fire. Then nothing. I asked what it was we had seen. 'Father Christmas in his aeroplane', she said, 'bringing the toys'. Many years later, I asked again. 'A doodle-bug', she said, 'a V-1 flying bomb'. The street of houses by the factories was levelled by bombs, then rebuilt. It formed an edge of the district of Grimesthorpe, but I went to school in the adjoining district of Brightside. The boys of the two districts were almost perpetually at war. Once, going home from school, I was ambushed and beaten by boys from my own class. Hostilities had flared between 'Brightys' and 'Grimeys'. I had been reclassified an enemy alien. I shared the volatile frontier condition with my cousin next door. Together we would make the journey to school down a road that ran parallel with the railway tracks. We called it 'The Long Road'. A wall separated us from the railway line, which we would climb in order to watch passing trains. We crossed the line by a bridge that led directly to the soot-blackened cliff of school buildings on the other side of the tracks. I felt a shock of recognition when I first saw this photograph by Bill Brandt. I am one of those children, running from school at 'home time'. Brandt made the photograph in Halifax, a factory town not far from Sheffield, but which I have never visited. Sheffield no longer has a steel industry. Bankers have accomplished what bombers failed to achieve. The street remains, but where the furnaces were is nothing but waste ground. The community of steelworkers is gone. Making nothing of steel, Sheffield makes no sense.

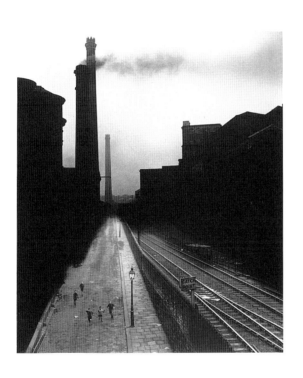

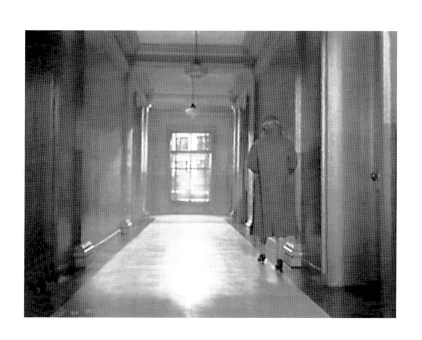

For migrant children of the north, the long road leads south. Here they find that though they have learned to read, they must yet learn to speak. As a child, I spoke Yorkshire dialect. (The Irish Joyce wrote, 'My soul frets in the shadow of his language'.) In London, the most traumatic displacements of workers occurred between the late 1830s and the 1850s. The 'clearances' razed entire neighbourhoods, displacing tens of thousands to make way for such 'improvements' as new roads. It is little appreciated that this form of social engineering was a British invention. Baron Georges-Eugène Haussmann began his *percements* of the working-class quarters of Paris only in the late 1850s. In 1909 Daniel Burnham, responsible for the planning of Chicago, wrote: 'The task which Haussmann accomplished for Paris corresponds with the work which must be done for Chicago in order to overcome the intolerable conditions which arise from a rapid growth in population.' Wherever 'strategic beautification' is practiced its purposes are the same: to disperse a labour force become superfluous to needs, thereby eliminating the possibility of organized revendication, and to recycle living space for 'redevelopment' profit. London 'improvements' were inflicted on working people with the poverty of style characteristic of wealth in protestant countries. Haussmann distinguished himself by the aesthetic superiority of his brutality. He called himself *artiste démolisseur*. In effect, he was was a stage designer. Haussmann's boulevards provide spectacular perspectives. The façades of the buildings are harmonious, as is all the street furniture. The breadth of the streets allows luxuriously wide pavements. Here, those Parisians who could afford it might both parade and take their turn in the audience at a pavement café. The newly perfected camera was the means by which this emergent form of participant theatre became self-conscious – at least after the lifting, in 1890, of legal restrictions on photographing on 'la voie publique'.

14

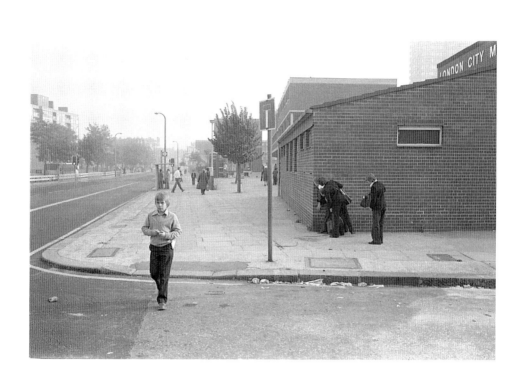

At the bottom of the Kings Road, near Sloane Square underground station and the Royal Court Theatre, the bus for Oxford Circus stops in front of a branch of W. H. Smith. Here commuters buy paperback best-sellers, newspapers and glossy magazines. Interminable ribbons of printed words swirl about each blink of the eye. As I took this picture, the current issue of *Vogue* magazine was gushing:

White, naturally, takes pride of place, but evening white lightly touched with silver or sometimes gold. Mayfair colours are almond pinks and green, dove greys and blue with the occasional appearance of what can only be described as peach. But what a peach – a delicious soft peaches-and-cream peach. Jewellery is kept to a minimum, just simple pearls and diamonds. Not necessarily real, it is the non-colour that is important. The look is essentially luxurious, very much for the pampered lady dressed for a romantic evening with every element pale and perfect.

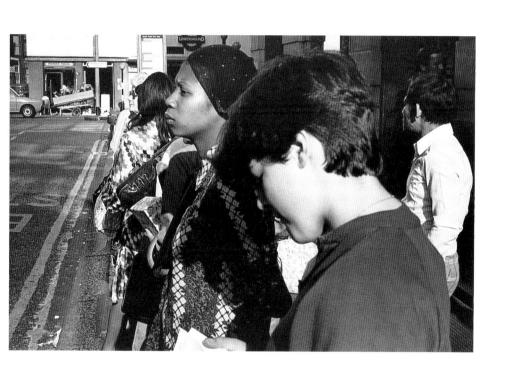

Meanwhile, the *Daily Telegraph* women's page pronounced:

St. Laurent demands a whole new lifestyle

Hips matter a lot. By day each dirndl skirt is stiched firmly down over the hips or else there is a suede hip yoke. By night black velvet camisole bodices extend down over the hipline then the bright taffeta skirt springs out free. Yves's day-time clothes, like his ready-to-wear three months ago, are a ramble through Eastern Europe.

I took this photograph for a trade union publication, and later used it as part of a gallery work. The city is Coventry.

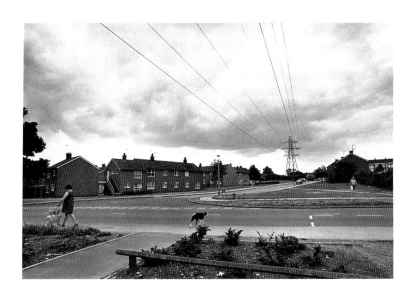

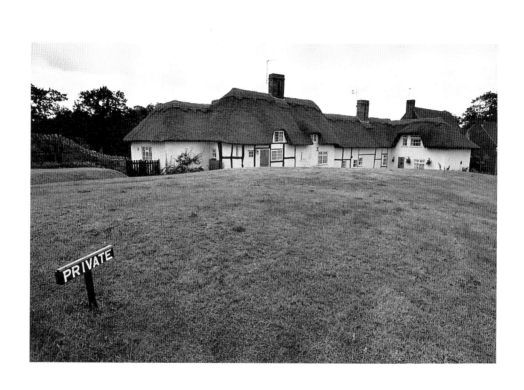

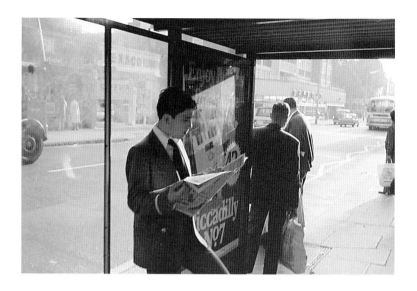

Back on the Kings Road, the State-sponsored destruction of working-class organizations was something to read about in the newspapers. Until the time came when there seemed no longer anything to read about.

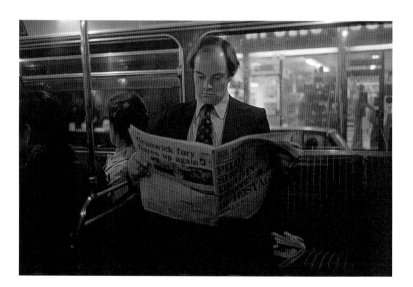

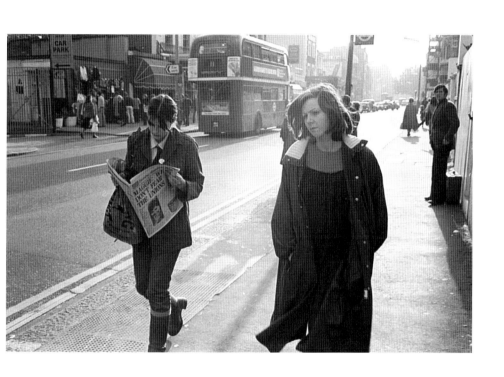

Work is one inescapable imperative, the other is love. Both meld in the romance of consumption staged on the Kings Road. The Romantic loves most what is least accessible. Hence, most banal and most true of clichés, the British love the sun. These images of the Kings Road catch some reflected sunlight of a single Saturday afternoon.

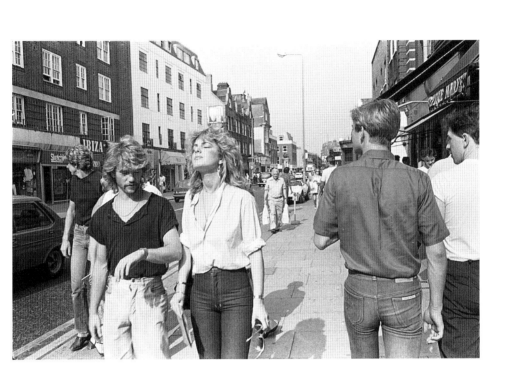

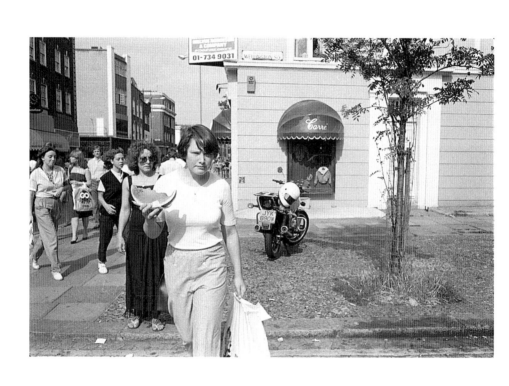

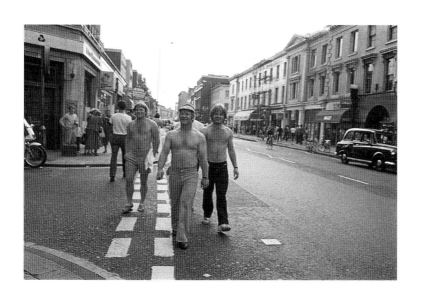

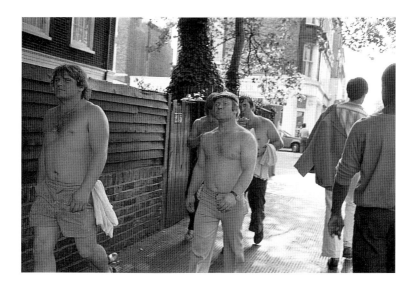

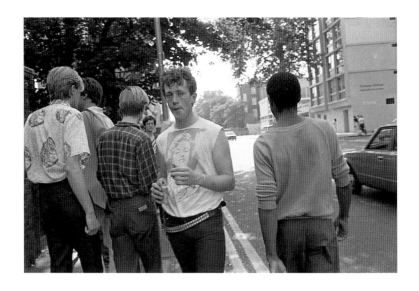

At that time, for the young seducer, this functionally redundant belt was an indispensable lure.

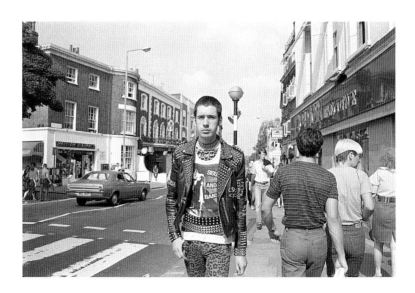

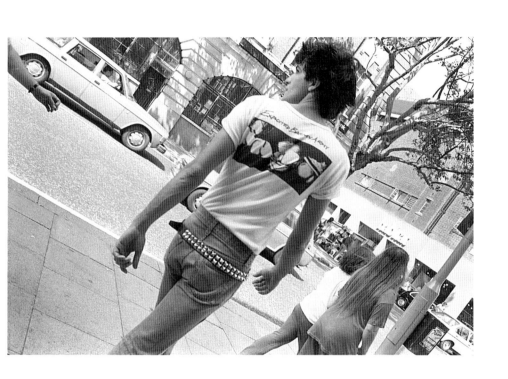

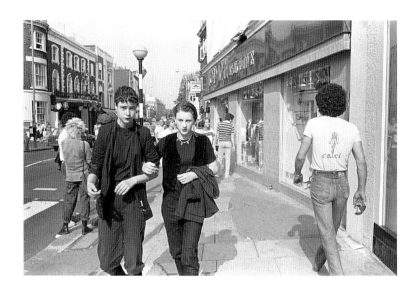

I passed this couple on my way down the Kings Road. Our paths crossed at the same point as I was on my way back. Here, the search for a thing and the search for a person are inseparable. Persons and things found are paraded in triumphant procession.

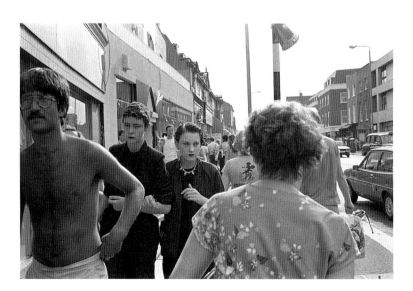

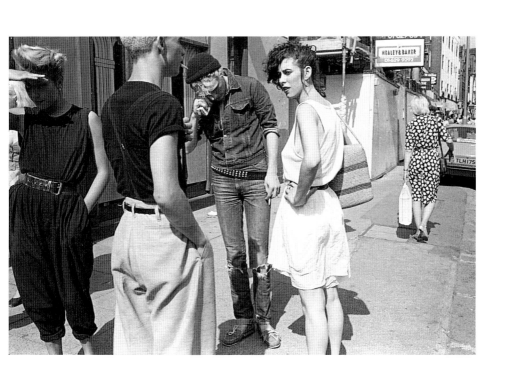

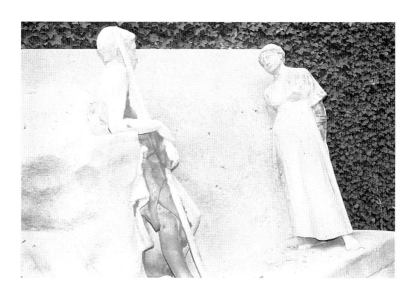

The picture opposite reminds me of a sculpture I photographed in Paris, in the garden of the church of Saint-Germain-des-Prés.

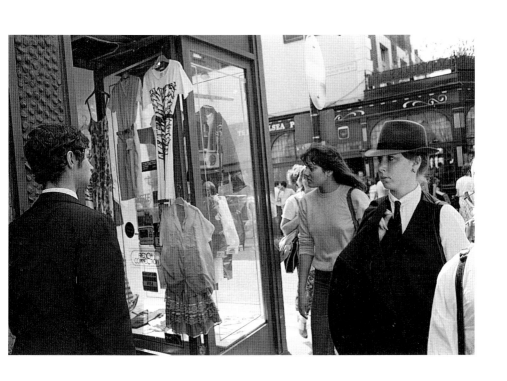

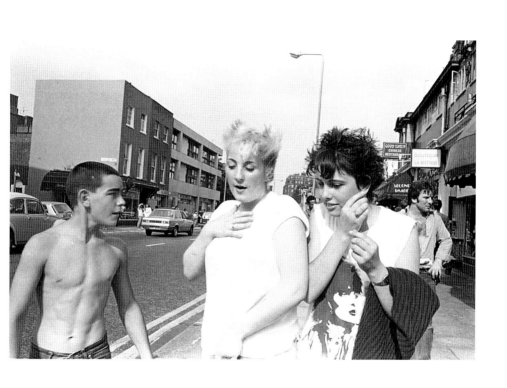

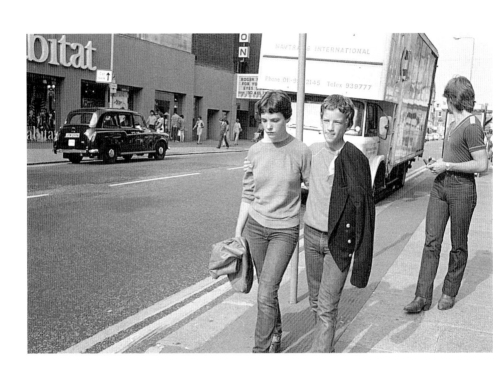

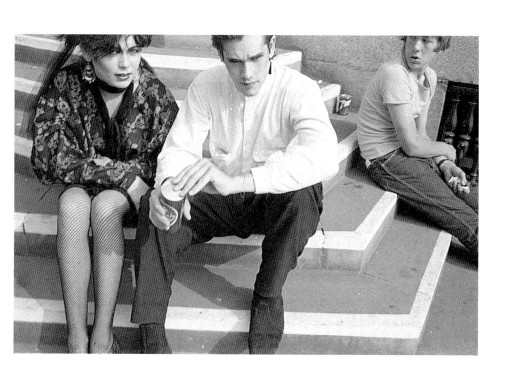

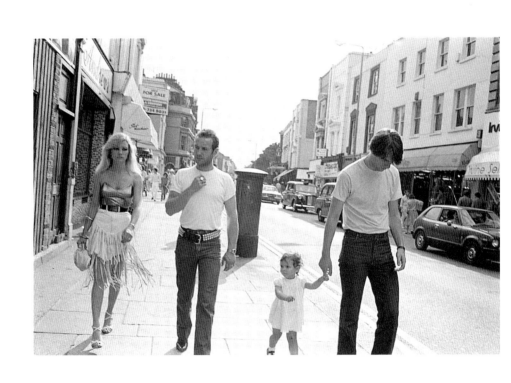

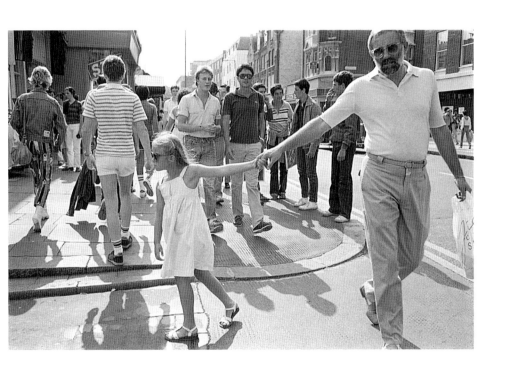

First in black Sheffield, then in white London, dreams of France and the US. The USA represented modernity – skyscrapers, freeways and jazz. France represented intellectuality – philosophy and poetry. As a schoolboy I had fallen in love first with Ava Gardner (*One Touch of Venus*, I was eight), then with Brigitte Bardot (*Et Dieu Créa la Femme*, I was fifteen), then with a schoolgirl who looked like Bardot. It was hopeless. I looked nothing like James Dean. In psychoanalytic terms, the successsive objects of our love are substitutes for an original lost part-object. The street is where we involuntarily shop for replacement parts. 'Love at last sight', Walter Benjamin called it, reflecting on Baudelaire's poem 'To a Passing Woman'. The essential is that one should pass. The disillusion of love is almost invariably guaranteed by the passage from the generality of the image to the particularity of the individual: to their speech – which is to say, to their work. We may not always do what we say, but we always say what we do.

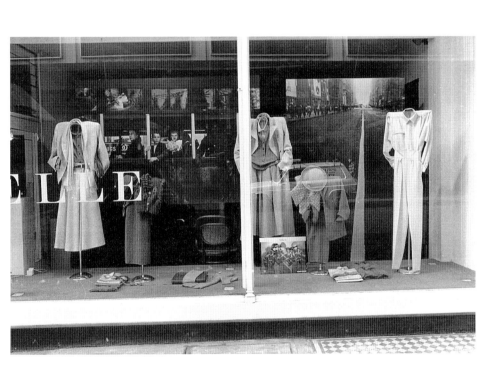

There is no equivalent to the Kings Road in Paris, where the erotic of the street is diffused throughout the city centre. In London terms, the tourist haunted area around Les Halles is half Kings Road, half Soho. (I would have to travel further – to Melrose Avenue in Los Angeles – to feel I was back on the Kings Road.)

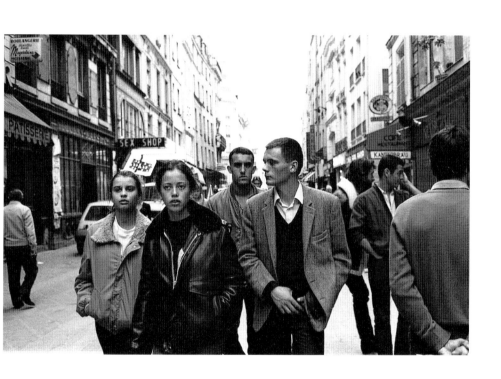

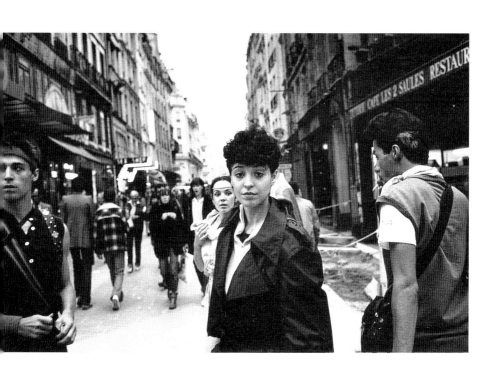

Love, labour and commodity coagulate – the shop window of the Paris exhibition of an American photo-realist sculptor. Before the Second World War, Paris was the centre of the art world. American artists had to do time there. After the war, European artists had to pay dues in New York.

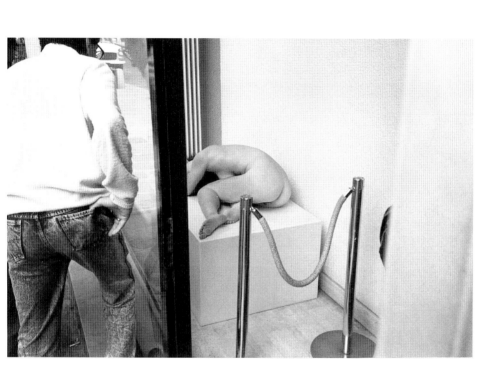

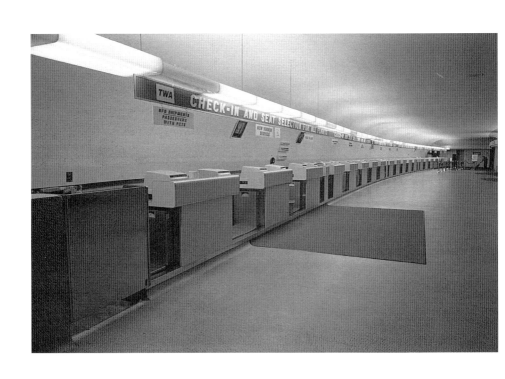

Hollywood had taught English schoolboys of my generation that America was a Never-Never Land, where Peter Pan need never grow up.

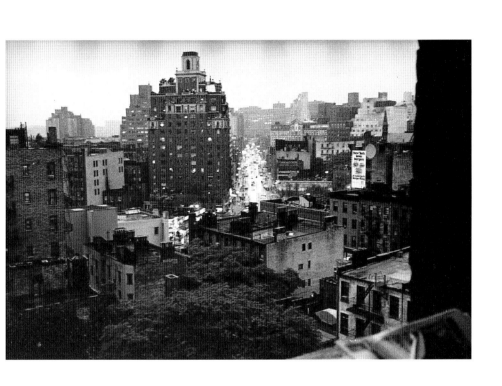

CRYSTAL BEAVERS WITH GARNET EYES

Designed by Lloyd Atkins

STEUBEN GLASS

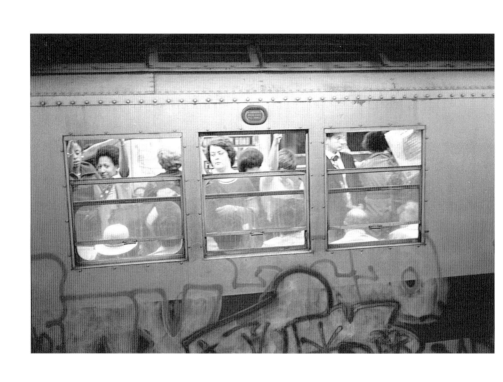

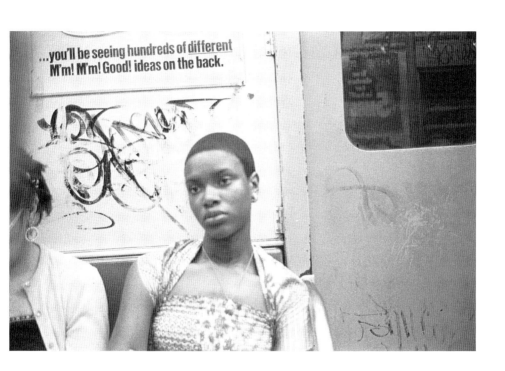

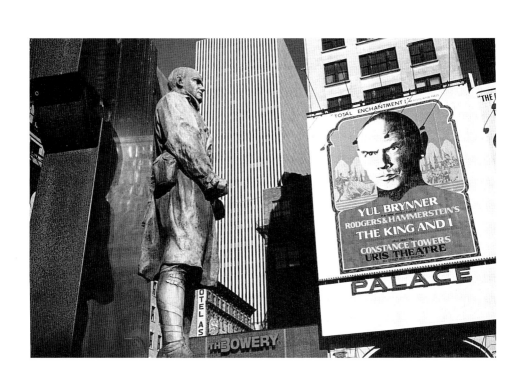

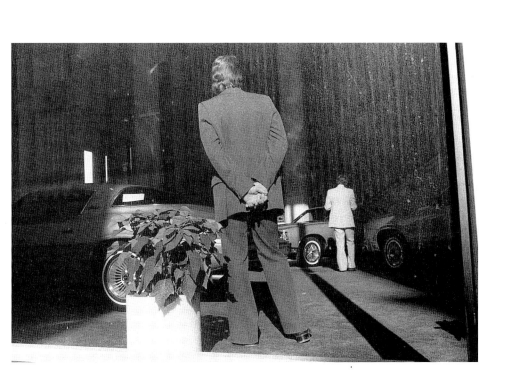

Europeans brought an alien technology of space-time travel to America: perspective. With its aid, their clearances and *percements* devastated a continent. To this day, newly landed Europeans are drawn inexorably along its axis to the West.

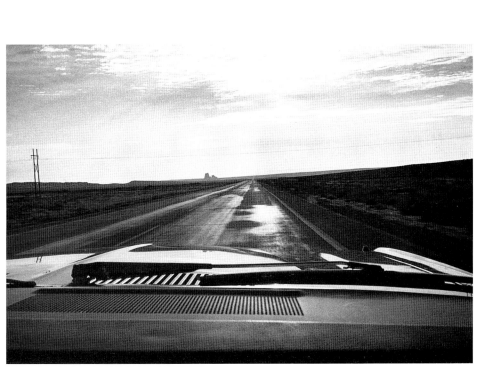

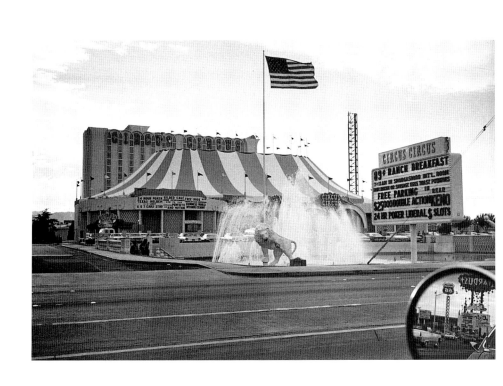

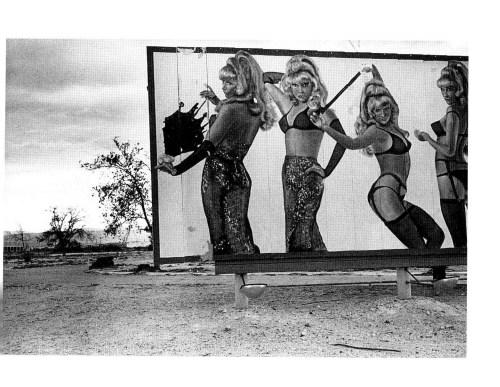

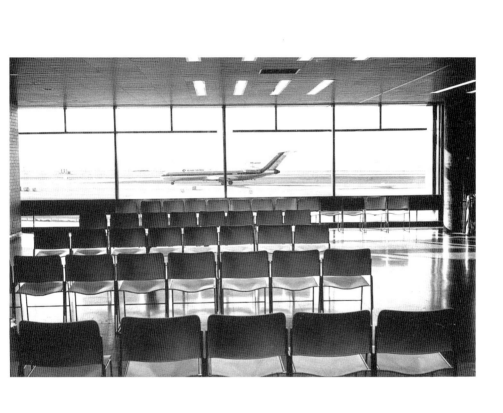

On deplaning in Los Angeles, I rented a car and headed out.

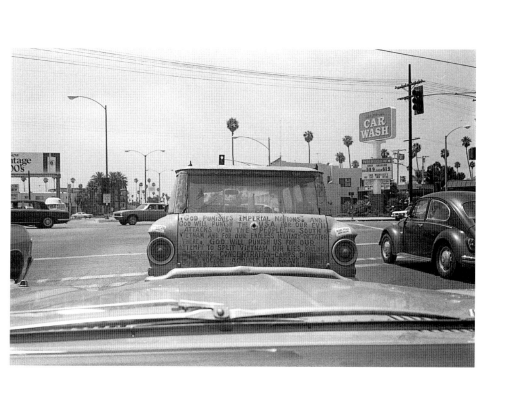

The next frame on the roll…

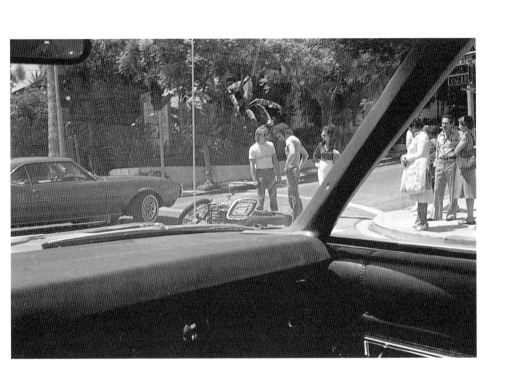

And the next frames… I was in the white car. The car which ran into me had swerved to avoid a third car, which had abruptly left the curb. The abrupt driver was exchanging insurance information with me when she shrieked and ran. I took this shot as I ran to help. Too late. She had failed to put on the hand-brake and the vehicle was now rolling backwards down the hill. It gathered speed and ran into a fourth car parked on the opposite side of the road. Contemplating the carnage, the woman flashed a smile and asked: 'Is that a British accent? Are you in the movie business?'

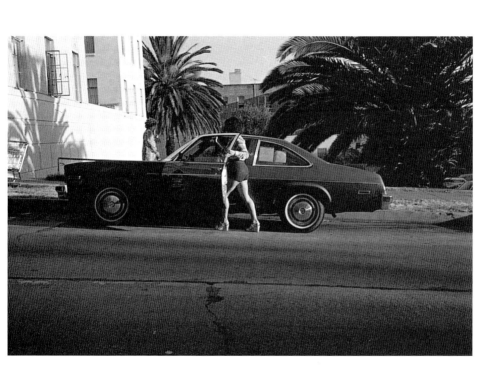

Frame 32… I had called the rental company. No problem. I could simply exchange the damaged car for a new one. As a child at Sunday School I had learned: 'Neither a borrower nor a lender be'. Such post-war British values had not yet been exposed to the advantages of automobile rental in the greater Los Angeles area. Here, refracted through the prism of industrialized fantasy, the westward perspectival prospect is projected beyond what the voice over the original *Star Trek* titles called 'The New Frontier' – to a vanishing point in God's own back yard. What hardware is actually available follows from Cape Kennedy.

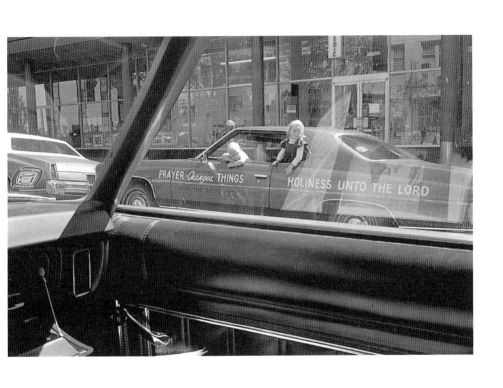

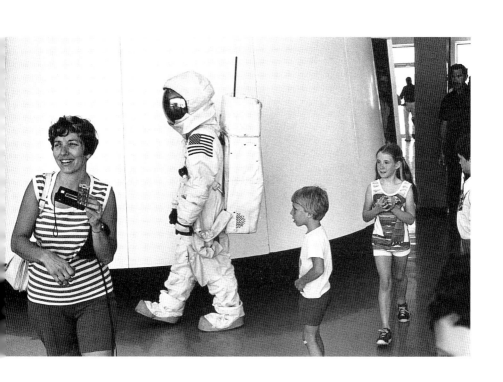

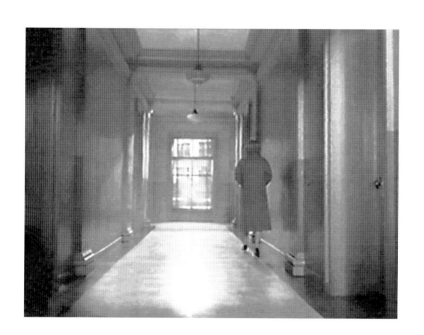

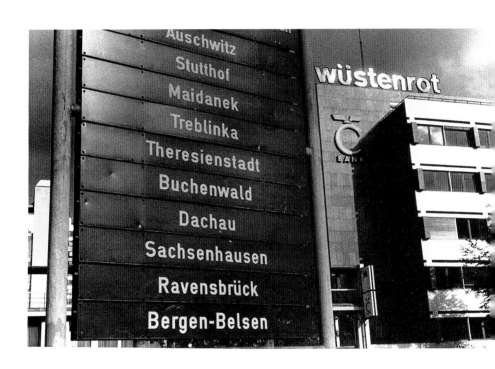

Berlin at that time was the showcase of capitalism.

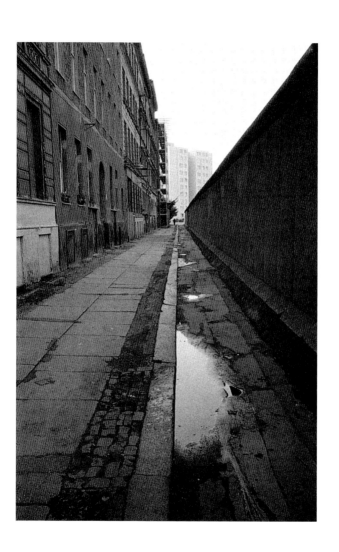

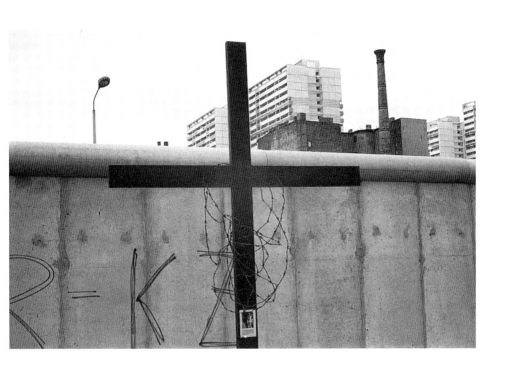

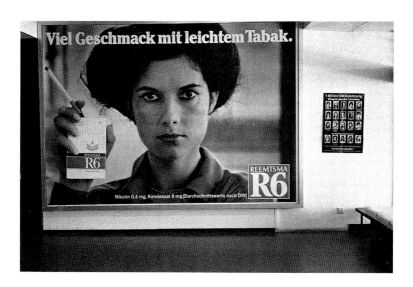

Almost everywhere I turned there were posters showing wanted terrorists. I first thought the display case on the Kufürstendamm was devoted to more terrorist mug-shots. But it proved to be a four-sided exhibit of 'before and after' pictures advertising the services of a plastic surgeon.

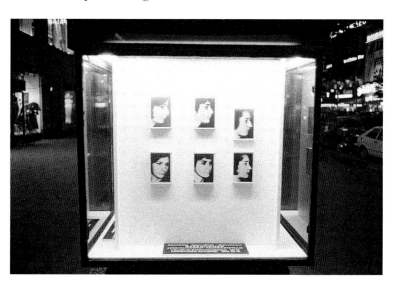

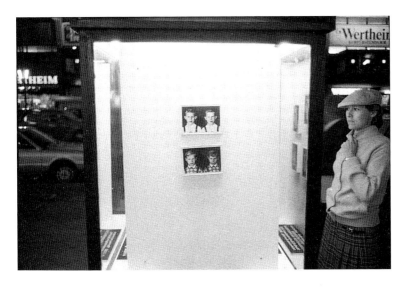

A few minutes walk from here is the 'Zoo' district. It comprises not only a zoological garden, but also the main railway station and a concentration of peep-shows. Publicity for the peep-shows proclaimed 'New from the USA', but I had heard of no such thing before I flew to Berlin from New York. I was reminded of the chapter on Jeremy Bentham's Panopticon prison in Michel Foucault's book *Surveiller et Punir*. The work I made in Berlin invoked overlapping surveillance systems: the peep-show, the spectacle of imprisoned animals, and the ubiquitous mutual watching across the Wall. I was reading *Zoo, or Letters Not about Love*, by the Russian Formalist critic Viktor Shklovsky. The book was first published in 1923, while Shklovsky was living in exile in the Zoo district. Shklovsky had been active in the wrong left-wing organization during the revolutionary period, and had fled Russia to avoid arrest by the Bolsheviks. He had fallen in love with Elsa Triolet, a Russian writer living in Paris. Triolet asked Shklovsky not to write to her about love. Shklovsky wrote to Elsa: *You gave me two assignments. 1) Not to call you. 2) Not to see you. So now I'm a busy man.*

A woman dances on a circular revolving stage within four walls of booths the size of telephone boxes. A window in each booth looks onto the stage, but only when a coin is put into a slot, causing a blind to be withdrawn: '1 Minute – 1 Mark'. The stage is lit, exposed. The cells are in darkness, their occupants concealed.

The plan of the Panopticon prison is circular. At the periphery there is an annular building. At the centre is a tower, pierced with many windows. The building consists of cells. Each cell has two windows: one in the outer wall of the cell allows daylight to pass into it; another in the inner wall looks onto the tower – or rather is looked upon by the tower, for the windows of the tower are dark, and the occupants of the cells cannot know who watches, or if anyone watches. Feeling watched at all times, each prisoner internalizes a jailor who never sleeps.

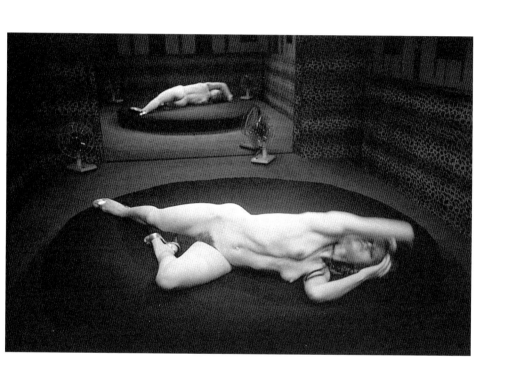

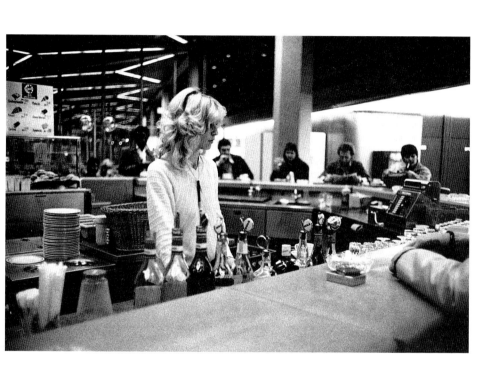

Shklovsky was unhappy in Berlin. He wrote to Elsa:

Naturally, the ape languishes without his forest…
All day long, this wretched foreigner languishes in his indoor zoo.

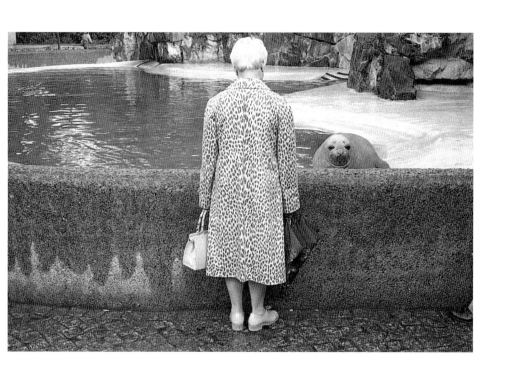

He wrote:

In Berlin, as everyone knows, the Russians live around the zoo.

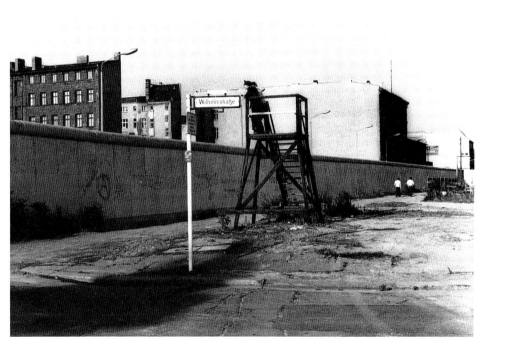

I later became one of those who lived around London zoo.

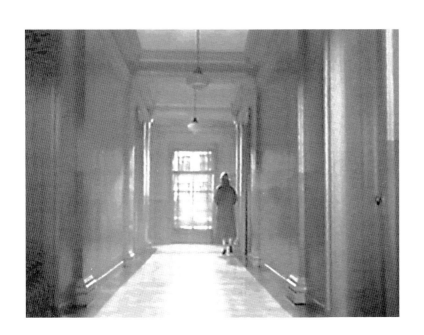

Lyon was built to divert. Following the death of Julius Caesar, the Roman Senate was afraid that Caesar's former lieutenant Lucius Munatius Plancus might combine his own troops with those of the mutinying Marc Antony. To keep his mind off revolution, they ordered him to build a city at the confluent of those rivers that are today the differently gendered 'la Saône' and 'le Rhône'. The merging rivers divide Lyon into three parts. The most salient architectural features of the city commemorate three distinctive moments in its history: the extensive excavations of Roman buildings (Fourvière); the even more extensively preserved medieval and Renaissance quarter (Vieux Lyon); and the aggressively 'contemporary' commercial centre (Part-Dieu).

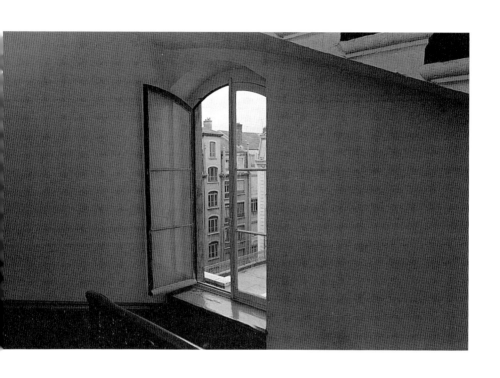

Not personifications of the confluence of the Rhône and the Saône, but a poet and his muse. (A *New Yorker* cartoon shows a despairing writer at his desk, surrounded by crumpled sheets of paper. His muse has just flown in the window. 'Sorry', she says, 'no ideas today. But I've put in a word for you with the NEA.')

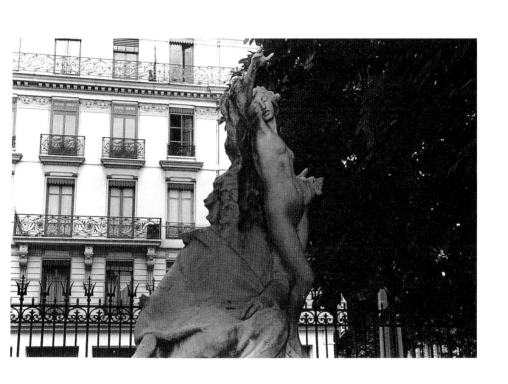

The Romans cut an amphitheatre from the side of the hill of Fourvière. A cathedral now stands at the summit. During the nineteenth century, at the time of the Prussian invasion of France, the bourgeoisie of Lyon congregated in the modest church on the hill. In prayer, they offered a deal to the Virgin. If she halted the advance of the Prussian army before it reached Lyon, they would build a magnificent cathedral in her honour. Lyon was spared, and the cathedral was built. However, no detailed specifications had been entered into the contract with the Virgin, allowing some economies on the final project. Adorning the façade, carved angels mount in tiers to the summit of the building. The higher the angel, the less detail in the carving. The most high angels, furthest from the mortal eye, are mere rough-hewn blocks. Ground floor angels are finely detailed, but look puzzled, as if contemplating the riddle of their difference from their counterparts. The winged lion represents the name of the city. From behind it resembles a Sphinx.

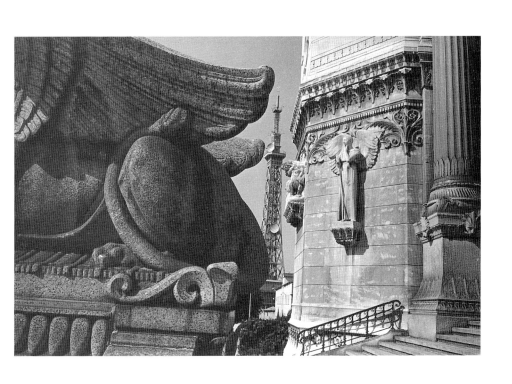

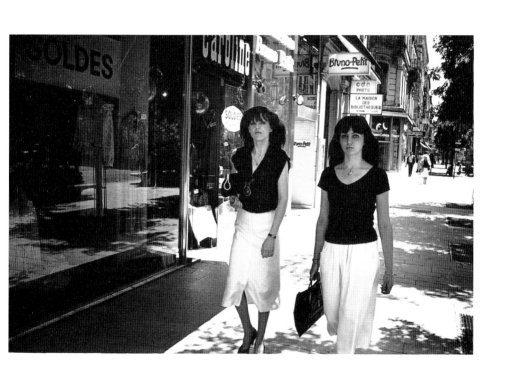

Not far from Lyon is Grenoble. I was asked by the Museum of Painting and Sculpture to make a work that would establish a link between their seventeenth-century collection and the contemporary city. For many years Grenoble had been administered by socialists. Their most ambitious project had been the building of a satellite city on the periphery of the old city of Grenoble. The site of 'Villeneuve' is surrounded by mountains. It is carefully landscaped and provided with artificial lakes and open-air swimming pools. There is a mix of high and low-rise housing and a variety of rents. The project was intended mainly for the benefit of workers, but there were incentives to attract other economic classes to Villeneuve. The new school of architecture was built as an integral part of the Villeneuve complex, and architects involved in the design of Villeneuve were required to spend a period of time living there. Villeneuve was to be a socialist Utopia. I juxtaposed this Utopia with the utopian scene depicted in a Claude landscape in the collection of the Museum. I was given an apartment in the museum itself. When I went out in the hot summer evenings, I lugged around two huge iron keys which allowed me back through the heavy ornamental gates and the monumental main doors. I then wound my way through coldly dark and silent corridors and exhibition halls to the door of my apartment, opposite the Egyptian mummies.

110

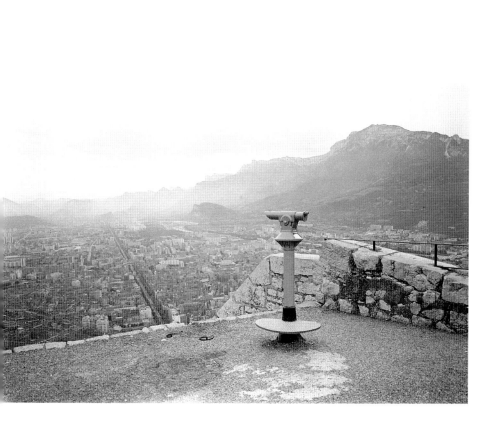

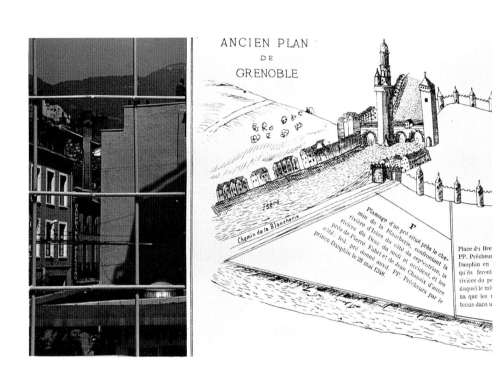

ANCIEN PLAN
DE
GRENOBLE

Isère

Chemin de la Blancherie

Plassage d'un pré situé près le che-
min de la Boucherie, confrontant la
rivière d'Isère du côté du septentrion, la
rivière du Drac du côté du midi et occident, et les
près de Pierre Fabri et de Jean Chanaix d'autre
côté, led. pré donné auxd. PP. Prêcheurs par le
prince Dauphin le 28 mai 1348.

F

Place d'1 Bre
PP. Prêcheur
Dauphin en
qu'ils feront
rivière du pe
duquel le mê
na que les
tenus dans u

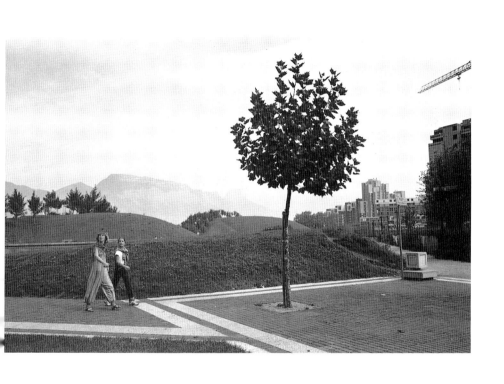

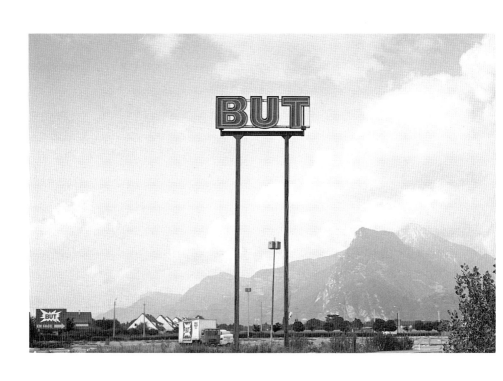

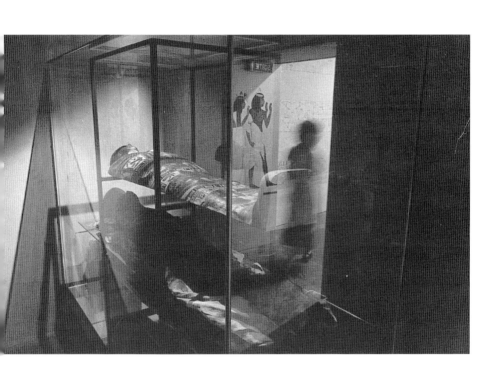

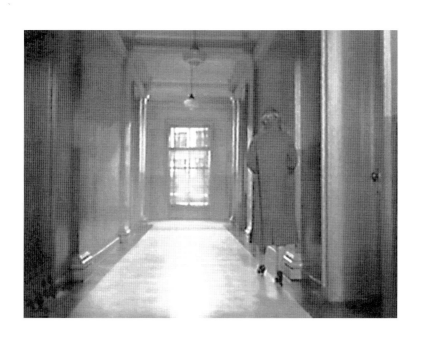

The windows of the Warsaw office of the British Council looked onto the Soviet-built Palace of Culture and Science. We drank Russian champagne. He reminisced about his tour of duty in Kenya. He has never since been able to eat pineapple, for there is nothing to compare with the taste of a pineapple taken fresh from the ground. There were no pineapples in Warsaw that October. The only fruits I saw offered for sale were a few poor looking apples. I was on my way to a meeting with the Union of Filmmakers and Photographers.

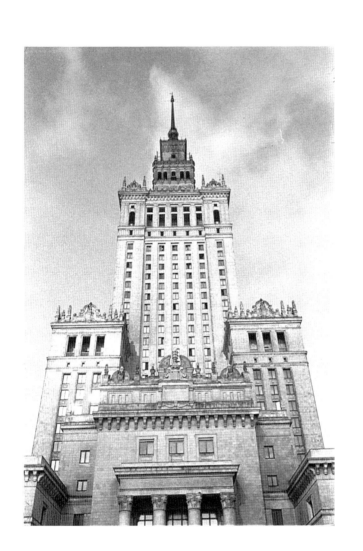

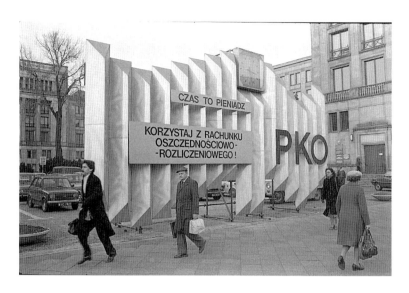

From Warsaw to Gdańsk. Excitement was high. A Solidarity intellectual told me that Communism would collapse in Poland, then in the Soviet Union. He said: 'Nothing can stop this'. Workers from the Lenin shipyard were building a monument to those killed fighting the police. Soon, Jaruzelski would impose martial law.

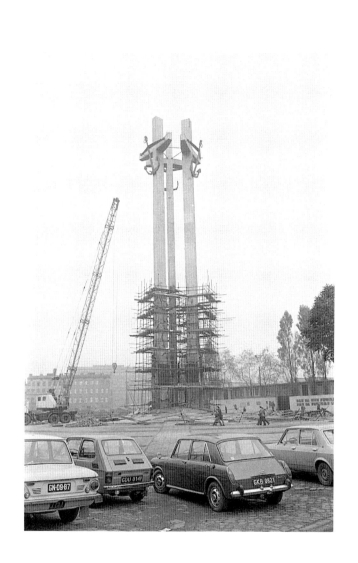

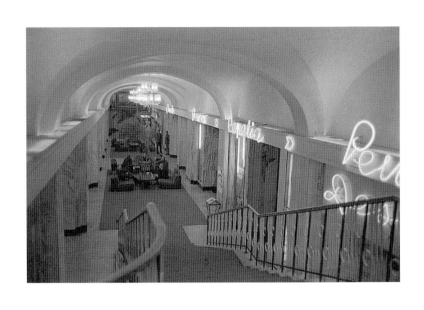

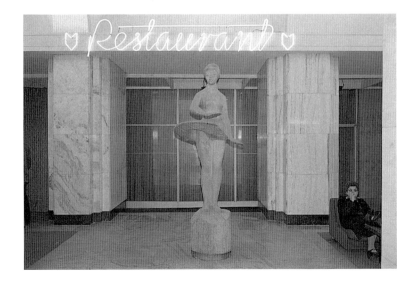

The train back from Łódź made frequent and incomprehensible stops. The last, longest and most frustrating of these was in lush fields within sight of Warsaw. Opulent cows grazed in great number by the tracks. That evening, after dinner in the hotel restaurant, I enquired if there was any coffee. I hesitated to ask. I knew coffee was hard to find. With evident pride, the waiter brought coffee. I casually asked if I might have some milk with it. He stiffened. Milk, he told me, was impossible to find – at any price.

It is hot in the restaurant. An extravagant display of long-stemmed chrysanthemums shields the pianist from the diners. His music has drifted East from *film noir* bars of decades ago. *I Fall in Love too Easily*. The dress looks like silk. Tight. Her face is angular, the nose prominent. She is leaving the table she shares with an older woman. *Don't Blame Me*. Now she is returning, striding past the chrysanthemums, through the thick smoke of cigarettes. One foot rests squarely on the ground; the other, arrested in its forward motion, touches the ground only with the tips of the toes. The moment is gone. No camera has recorded it. *Round Midnight*. Western journalists and businessmen converse with the women around the bar. They want to be liked. The women dip into their purses for mirrors, lipsticks and currency conversion tables. *Love For Sale*.

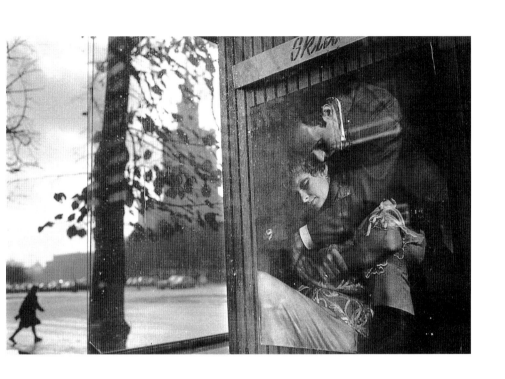

On the island of Tobago I pull my rented car off a pot-holed road in the steep hills of the northern coast. I have seen something startlingly familiar in this beautiful and unknown landscape. Rusted red above the track, half-buried in a tangle of thick green creepers and purple flowers, is a huge iron water-wheel. It resembles similarly eroding relics of manufacturing prosperity in the northern industrial landscapes of my English childhood. I climb up to it, picking my way over fallen stone walls all but hidden under the tropical vegetation. From here the eye commands a splendid sweep of bay, with palms leaning over a winding strip of beach. A bay, I imagine, where African slaves once loaded boats with sugar from the now ruined plantation factory. Written on the crumbling iron of this Ozymandias, I read: *A & W Smith & Co Glasgow 1871*. Even in Arcadia, I have found a monument to what Lacan called 'the barbarism of the Darwinian century'. Those in the West are all lost among such debris, the accumulation of rubble left behind in the accumulation of capital. Abandoned lives spent alongside the idly rusting machinery of former steel-towns; ruined lives passed in the ruined landscapes formed in the liquid wake and barren spoil-heaps of chemical industries and strip-mines; lives displaced from fertile farmlands prematurely buried under the empty real-estate 'developments' of the Reagan and Thatcher years. Those still with jobs are lost among the debris of the finest products of capitalism, left wandering in the mall.

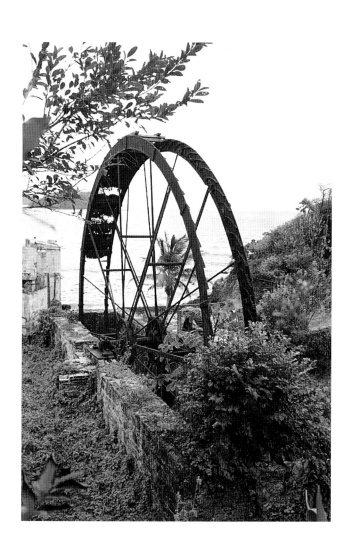

Malmö

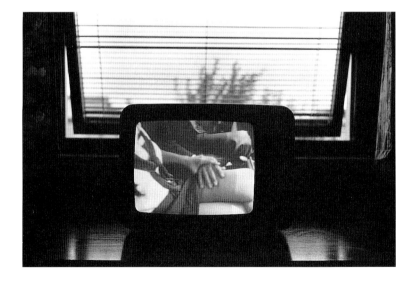

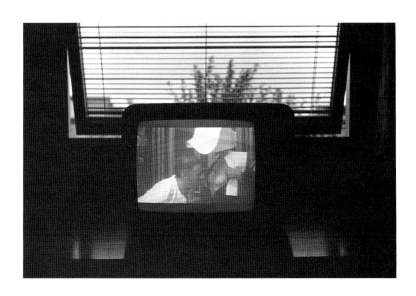

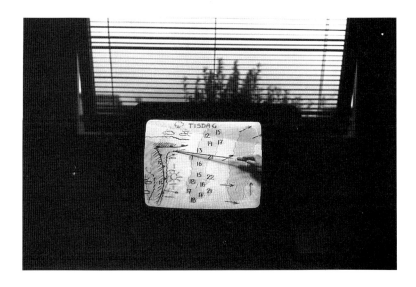

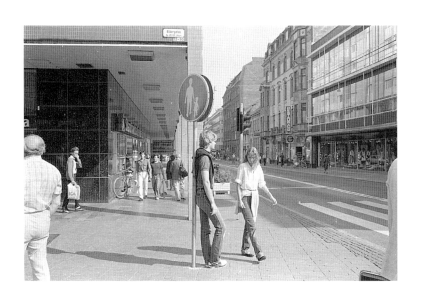

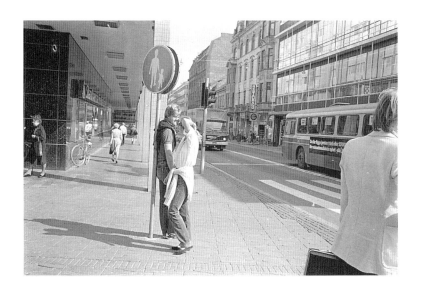

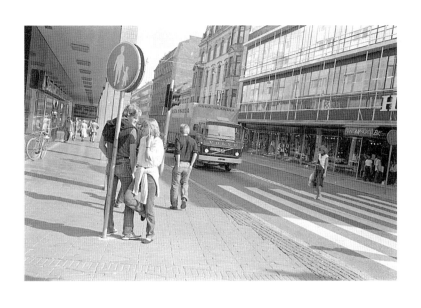

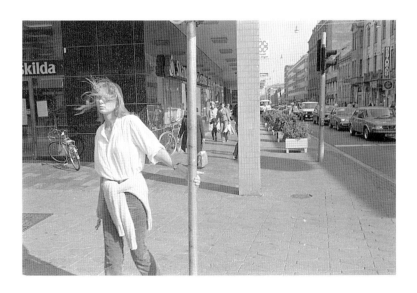

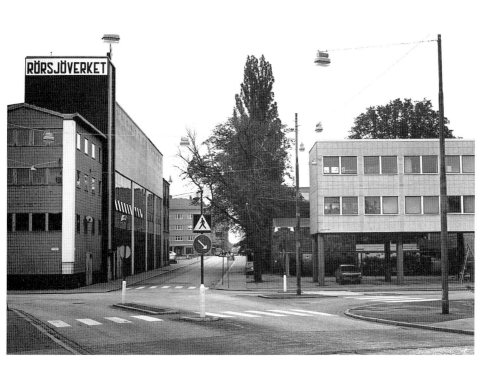

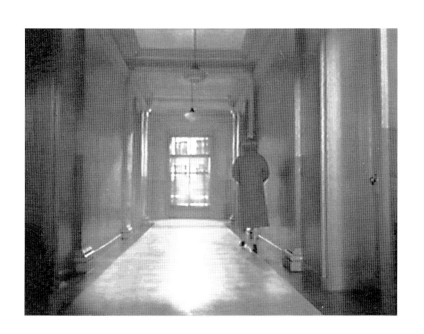

From the city of Perth, on the Indian Ocean, a road cuts straight across the desert of Western Australia. Between Perth and the remote opal-mining community of Coober Pedy there is only one desert town, Woomera. For me, the name came charged with boyhood memories. Woomera was where the British tested their rockets and missiles. I grew up with BBC radio news of the exploits of British rocket scientists. That was the time when the Royal Air Force named their latest bomber after the newly constructed seat of the Australian Government. I had a model of the 'Canberra' bomber which, with a twitch of the finger, would discharge a cargo of plastic bombs. In the town centre of Woomera I found a missile park, a Fifties-futuristic building, and a Canberra bomber. I had arrived in the furnace heat of midday, and the town seemed deserted. I felt I was in my own personalized episode of the *Twilight Zone*.

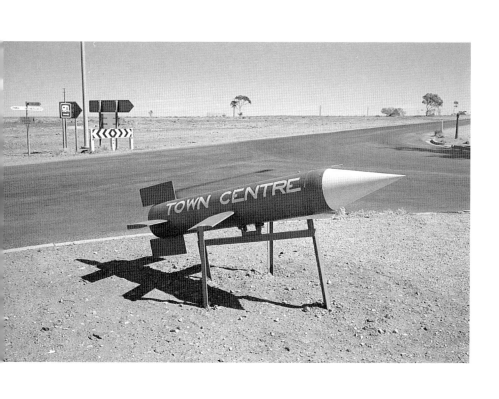

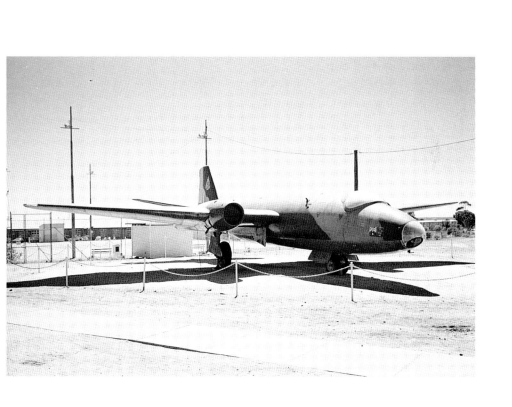

To escape the blistering heat of the desert, the miners of Coober Pedy live underground, carving home and workplace from the same rock. One miner had turned an exhausted mine into a museum for the few tourists, most of them Japanese, who come to buy opal. He had prospered since he moved here from England, and could now think of no other place he could live. 'What would I be doing in London?', he asked. 'Snatching bags from old ladies!' The walls of the underground motel carry the marks of the miners' drills, and pictures of gentler places.

THIS TREE REPRESENTS
THE REMAINS OF A BURNT OUT
TRUCK FROM THE EARLY DAYS
AND IS STILL IN THE...
UNPAINTED STAGE. IT WAS
THE 1ST TREE IN COOBER PEDY
Donated By CLAUS & GABRIELE HARRIES

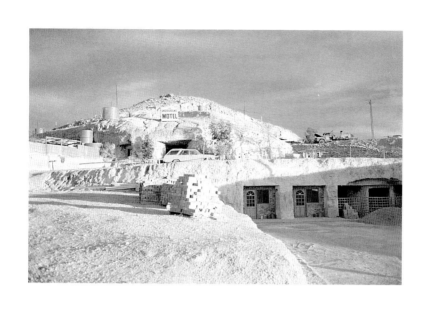

April in Tokyo. In Ueno park, picnics are laid under low-lying clouds of cherry blossom. Pools of beer spatter tarpaulin rafts bearing cargoes of revellers down avenues of trees. The banks of these asphalt rivers teem with sightseers, entranced as much by the spectacle of the picnickers as by the blossoms whose brief flowering – *momento mori* – provides the moral pretext for the party. The blossoms are piped into the Shibuya branch of the Seibu department store in the form of ambient video. Via monitors on all twelve floors, on the interlacing escalators, in the elevators, the images blossom in every corner of the store. Men sleep on couches at the edges of the spaces where, on successive floors of Seibu, the escalators change direction. Beneath the store, on the Yarakucho subway station, young women office workers sleep. They sleep commuting to and from the confines of the suburbs. At the weekend they return – to Shibuya, Ginza, Ikebukuro, or some other branch of Seibu. They buy clothes by Isse Miyake, Comme des Garçons, Yoshi Yamamoto, or some other designer whose work is hopelessly beyond the means of their European or American counterparts. Some 90 minutes by train from their tiny 'four-mat' rooms they pass the day in *flâneurie*. Countless petal faces drift through the hopelessly luxurious spaces of Seibu, spaces that open onto all space through the ubiquitous ambient video screens. On this floor, on a large monitor, in a single unedited shot, one crosses the Australian desert on an endless road. That is all. Nothing but perpetual motion through infinite space.

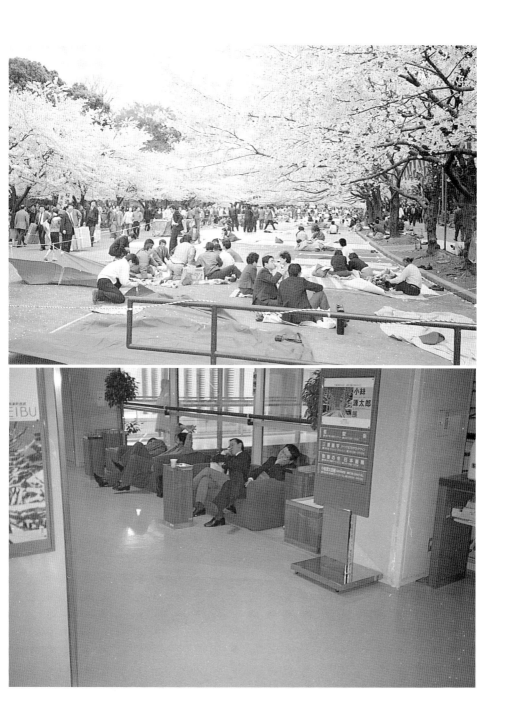

The towers of the new Singapore lurch through what remains of the old like city-ravaging monsters from a low-budget science fiction film. Although the sedate Palm Court of the Raffles Hotel seems about to be crushed there is no panic. Beneath the palms, without a breeze, perspiring residents sip Singapore Slings by the pool. A lavishly decorated Christmas tree wilts in the bathwater air. I go looking for the ruins of The Great World, a legendary and infamous pleasure garden of the 1930s. A cab-driver takes me to the site. There is nothing but manicured grass.

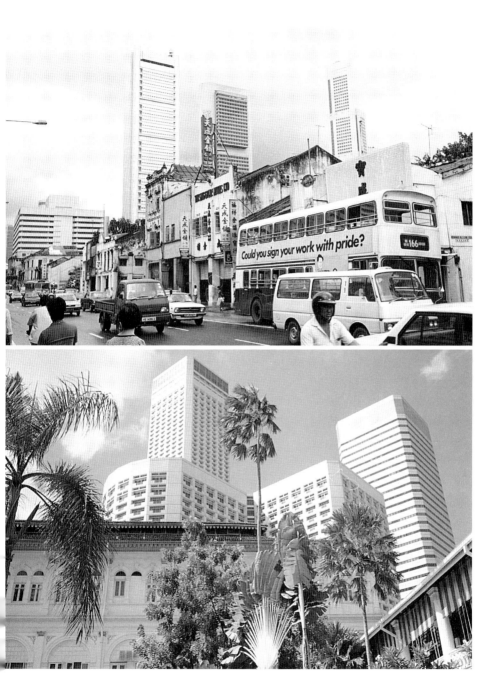

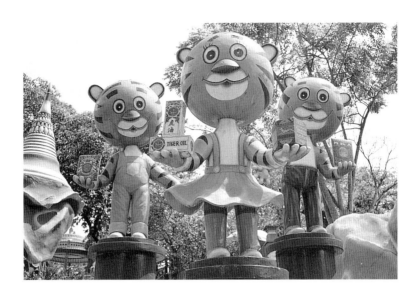

The Tiger Balm garden remains. The anonymous creators of its
moral tableaux might indeed have signed their work with pride:
The spectacle of a young woman singing leads inevitably to a fight.
A Nativity scene is played in local costume, with representatives
of the media as the Three Kings. Good boys just want to read books.
Progress around the garden is punctuated by sudden downpours,
as if water were slopping from some huge pail in the sky. On the
way back to the hotel, the sight of a snowman wearing a scarf is
suffocating. I witness the spectral second coming of a cathedral
from a painting by Constable, adored by Three Corporations.

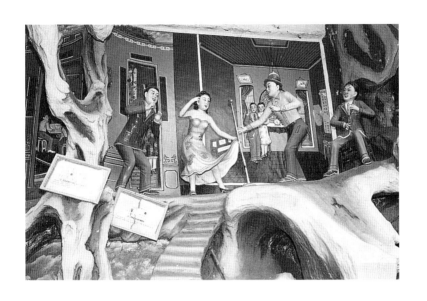

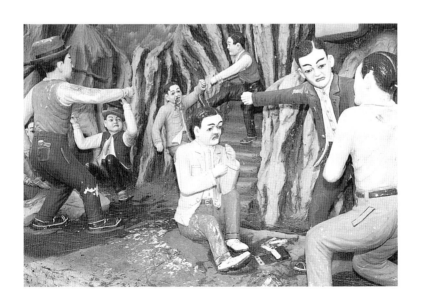

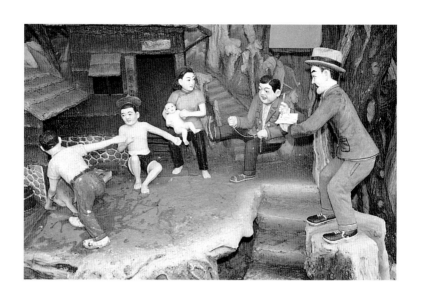

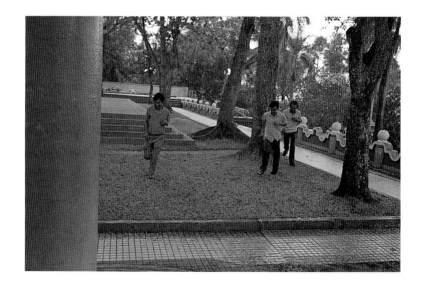

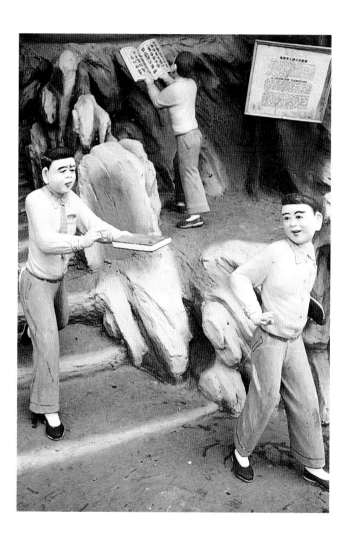

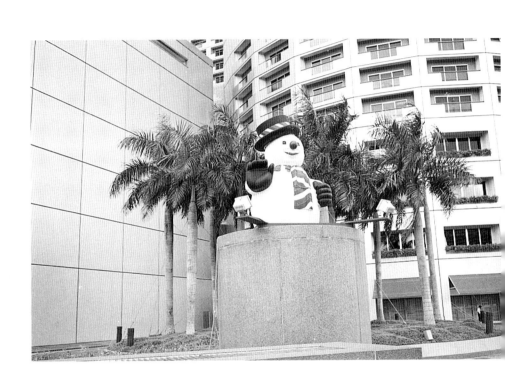

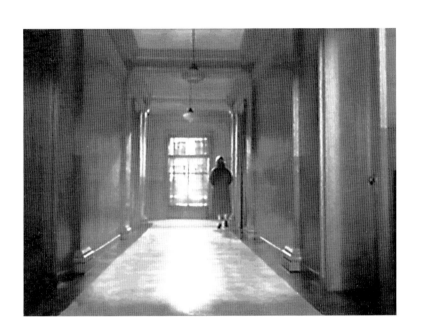

A dark triangle, rising from a flat sea, with a cloud of smoke at its apex. Stromboli is a child's drawing of a volcanic island.

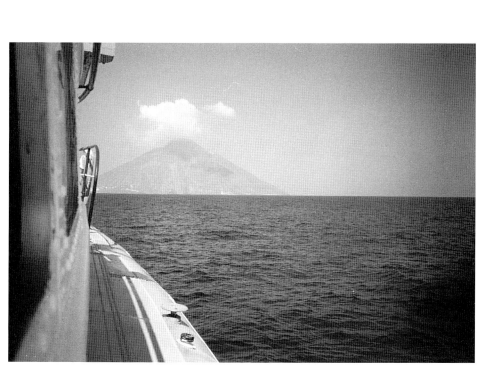

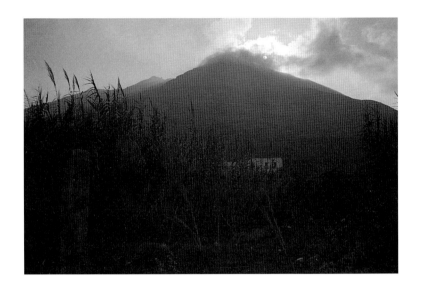

The village of Stromboli is between the volcano and the sea.

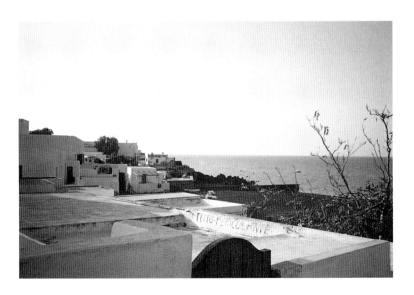

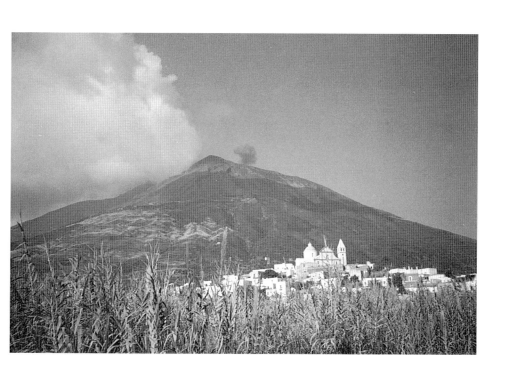

No 'development' here. To 'invest' would be unwise. Water must be brought daily from the mainland by ship, the island has none of its own. The volcano is unceasingly active. Day and night the mountain rumbles, spitting gobs of black smoke into the clouds at its summit. In the past, damage from eruptions has been devastating. The tourist office is small. On display are newspaper reports of visitors (almost all Germans) who fell to their death while attempting to climb the volcano, and of those who, having made it to the top, fell into the volcano. Nor is one safe in the water. On display is a huge boulder, coughed up from the interior of the mountain and dropped on the beach. There is also this poster.

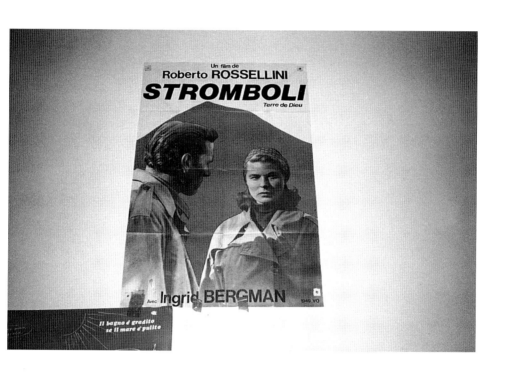

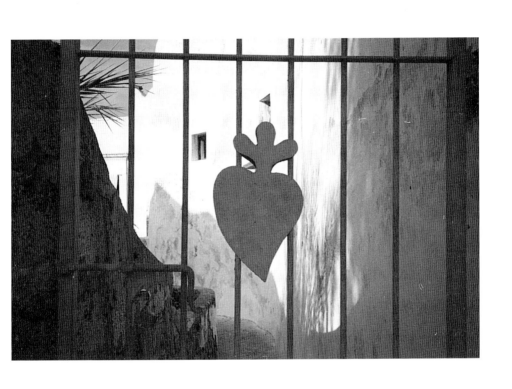

Inevitably, after days of swimming from beaches of black volcanic sand, of reading on white terraces overlooking the sea, you return to the path that leads to the volcano. You start early morning. You climb for hours. The path becomes steeply dangerous. Then village and sea are lost in smoke. Fear sets in. It is night when you return.

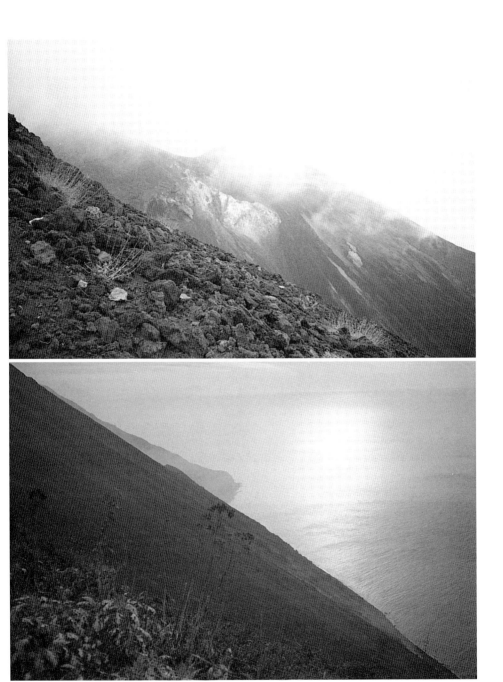

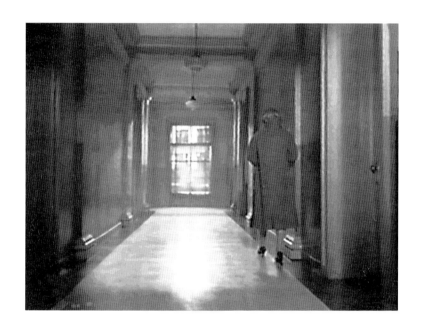

The city of Blois is divided not so much by the Loire, which flows through it, as by the railway-line that runs parallel with the river. The dominant relation between the northern suburb of Blois and its centre is comparable to that between centre and suburb in many other French cities. The suburb has the largest numbers of young, unemployed and recent immigrants. The centre has most of the shops, cinemas, cafés and other services. In some cities, railways connect centre to periphery. In Blois, the railway-line forms an iron barrier between centre and northern suburb, exacerbating feelings of division. A report produced by *l'Atelier Public d'Architecture et d'Urbanisme* notes: 'all inhabitants of Blois define themselves in relation to their "old town". They identify themselves with its castle, its narrow streets, its past. Or they reject it as an outmoded symbol. Often, these diverse attitudes reflect the social integration or exclusion of the individual.' The report finds that, for all inhabitants of Blois, the railway-line marks 'a sort of limit beyond which another city begins'. This common sense of the division of Blois is 'lived' more than it is a matter of conscious consideration.

174

In a study of 'images of the city in the crime novel' (Jean-Noël Blanc, *Polarville*) the author writes that his analysis will bear, 'not upon some supposed real city, situated somewhere in the world and which the crime novel would describe in the fashion of a touristic or geographic description, but rather upon the *city of paper* which the crime novel drafts: written, unreal, symbolic, *coded'*. But what the writer calls the 'real city' is never experienced simply as such, as *separate* from the 'paper city'. At the same time that the city is experienced as a physically factual built environment, it is also, in the perception of its inhabitants, a city in a novel, a film, a photograph, a television programme, a comic strip, and so on. For example, I buy a special issue of the weekly news magazine *Le Nouvel Observateur* devoted to youth riots in the suburbs. The cover photograph shows a graffiti image on a concrete wall. Armed figures occupy the foreground of the painting. Behind them rises the sprayed silhouette of a city-skyline that resembles, at the same time, *both* the low-income housing projects of the French suburbs and the characteristic cityscape of the American *film noir*.

Invited to submit a project, I wrote: 'The aim of the proposed work is to encourage conscious public reflection upon the division of Blois by way of a selective foregrounding of representations from the collective imaginary. The Blois with which the proposal is concerned is situated at the junction of the real and the unreal city. Undecidedly both factual and fictional, it is the city in the eyes of someone who has just seen a film by Chabrol, or read a novel by Chandler or Daeninckx. It is the city reflected in newspaper reports of other cities, in magazine and television representations of other moments in time and other parts of the world. It is at once Blois and its other: other utopias, other dystopias – the fictional double of Blois in a parallel universe or a distant future. At the generating centre of the proposed work is the physical fact of the railway track, and the separated spaces it creates. There will be no images of railway-lines, the division will be represented not literally but metaphorically. Rather than a sociological illustration, the work will rather be a fantasmatic *mise-en-scène*. Throughout, an attempt will be made to bring the suburb into equal representation with the centre. The work will consist of a series of posters distributed throughout the *quartiers Nord* and the city centre by means of the existing system of publicity panels. The posters will form an ensemble of images and texts representing, individually and in totality, imaginary cities and their divisions.' The proposal accepted, I began designing 'film posters' to promote a non-existent movie about a future Blois. Titled *Loin d'Ici* (*Far From Here*) the 'film' projected possible consequences of the rise of the National Front. The project was never realized (the image opposite is a montage). The money evaporated in the wake of the Presidential elections. I had, anyhow, become uneasy with the project. I had allowed the narcissistic satisfaction of venting my feelings about the NF to preempt the work of political consultation and calculation that alone should guide interventions in public places.

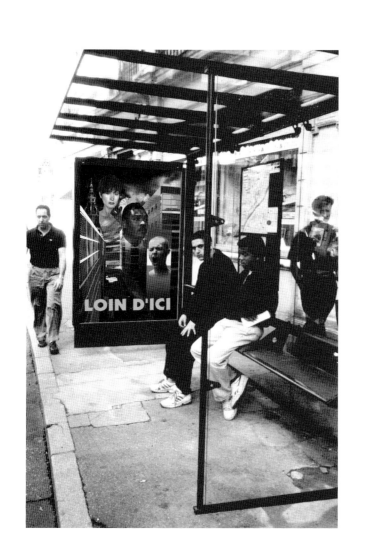

Multi-media libraries (*médiathèques*) are now rising in French cities alongside the old libraries (*bibliothèques*). The Médiathèque d'Orléans houses books and other printed matter under the same roof as video-tapes, CDs, and other products of newer information technologies. My intervention was invited, in 1993, at a late stage in the construction of the building. I had to shoe-horn my project into the existing spaces. The work was prompted by the simultaneous presence, in our daily lives, of the printed word and the electronic image: the book and television. The work consists of a large video projection screen suspended at a place of transit between the 'high tech' and 'no tech' floors in the building. A computer-controlled video system inserts textual citations from the printed archive into an endless stream of live satellite television images. There is no sound. The citations represent the vast totality of the *patrimoine* that is the archive of Francophone literature. The television images are drawn from as many parts of the globe as is technically possible, and are unpredictably current. The text-image combinations are therefore aleatory, and infinite in number. The citations – from writers as various as de Beauvoir, Fanon and Mallarmé – speak of history, memory and identity. Favouring the perpetually instantaneous, television tends to efface the continuity of memory and history necessary to stable identities. (In this respect, the library has become a 'counter institution' to television.) Identities form not only in time, but in space. Like other Western cities, Orléans today is a node in a multicultural society, which is in turn part of a global political economy. The old spatial and historical dimensions of the city of Orléans have collapsed into the black hole of the archive. Today, satellite television – and other forms of electronic communications indifferent to geographical and political boundaries – have consigned the expression 'city limits' to the realm of nostalgia.

178

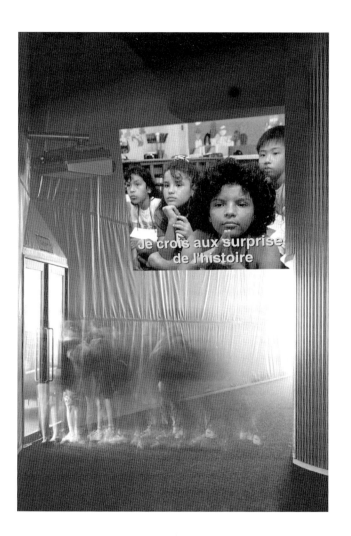

Je crois aux surprises de l'histoire

City on the Hill is the name of the student newspaper published at the University of California, Santa Cruz. The hill overlooks Monterey Bay, and the Pacific beyond. Jean Baudrillard wrote about the Santa Cruz campus in his book *America*. He said that being there made him feel as if he were in a 1950s science fiction film, in which the inhabitants of a small town in America wake one morning to find the entire town has been enclosed in a glass bubble. I know the film. Baudrillard chose the wrong one. Redwoods crown the hill, concealing most of the university buildings. From many places on the perimeter of the campus the view across the bay hesitates only at a narrow strand of meadows and tree-tops. Often the hill-top is in full sunlight, while the Pacific below lies under a layer of white fog. At other times the ocean is burnished by the sun. I feel I am in Andrei Tarkovsky's film *Solaris*. The planet Solaris is entirely covered by ocean. When Russian scientists land there, an island forms beneath them. The longer they remain, the more their environment takes on forms from their memories. Eventually, only one man remains on the research station. His wife comes to join him in his room. She turns so that he may unfasten her dress. His fingers find lace-holes, but no laces, and no division in the seamless fabric. In reproducing his dead wife, the planet has remained ignorant of such details of her garment. In the final scene of the film, the camera leaves the man back in his parent's house in rural Russia. An ascending aerial shot shows the house set in the fields that surround it. As the camera continues its ascent, it now reveals that the house is on an island of fields in the ocean of Solaris. We perpetually commute between Earth and Solaris. The signs that tell us where we are are rarely as eloquent as the woman in the unfinished dress.

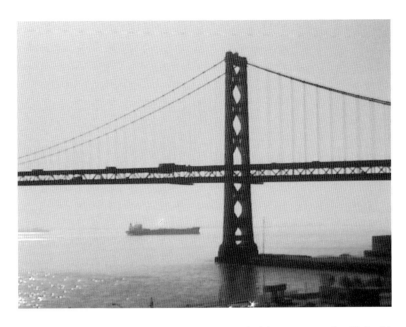

At an award ceremony in San Francisco, held in 1993 at the Kabuki movie theatre, the Senegalese novelist and film-maker Ousmane Sembène was presented with the Akira Kurosawa Award for lifetime achievement in film directing. The evening began with traditional Senegalese drumming. There then followed a screening of Sembène's film, *Guelwaar* (1992), which deals with religious and political conflict between Muslims and Catholic Christians in present-day Senegal. The dialogue was in Wolof and French, with English subtitles. The Kabuki theatre is on the edge of San Francisco's Japantown, which is separated from the mainly African-American neighbourhood to the South by Geary Boulevard – a thickly flowing eight-lane river of automobiles. Jack's Bar, alongside the Kabuki, is a fragment of African-American cultural history now stranded amongst sushi bars and Oriental gift shops. On the walls are large photographs from the 1940s of Joe Louis, surrounded by admirers at the bar, and of John Lee Hooker, performing on Jack's small stage.

182

In my psychotaxonomy of San Francisco, Jack's Bar is classed together with other such intimately individual out-of-place fragments. For example, to the west of Japantown, in Golden Gate Park – stranded between John F. Kennedy Drive and Martin Luther King Jr. Drive – is the Japanese Tea Garden. Apart from the Hollywood-Orientalist typography that disfigures some of its signs, the garden is still, a hundred years after it was created, almost completely Japanese in design. On leaving the garden, it would be easy to miss the small bronze plaque set back among foliage by the exit. It reads: 'To honor Makato Hagiwara and his family, who nurtured and shared this garden from 1895 to 1942'. It says nothing more, and the historical silence that follows has only recently been broken. The year 1942 was the year in which the U. S. Government introduced the 'Civilian Exclusion Orders' that dispossessed over 110, 000 Japanese-Americans, and confined them to concentration camps on some of the most barren lands in America. In a recent book about one of these camps – the one at Manzanar, a day's drive from San Francisco – I read: 'Manzanar, which means "apple orchard", was named by the Spanish [...]. At one time it was a fertile place, but in 1919 the farms of the area were bought up by the Government. The water they depended upon was diverted into the massive Los Angeles Aqueduct to serve that growing city, and as a result, the Owens valley degenerated into a man-made desert.' Whether correctly or not – psychohistory being no more attentive to empirical truth than psychogeography – I imagine the Hagiwara family cultivating the desert at Manzanar. Sembène's film, *Guelwaar*, concludes with a scene in which Senegelese poor destroy a truckload of UN relief supplies (freedom from neocolonialism requiring that 'independence' be observed to the letter). The camera leaves them grinding the grain into the arid road.

What was to become the port city of Marseille was first established by the Phoenicians, around 600 BC. The city of 'Massalia' subsequently developed through waves of settlement by other peoples from the Mediterranean basin and beyond: Greeks, Italians, Spanish, Corsicans, North Africans, sub-Saharan Africans, Armenians, Vietnamese and, most recently, immigrants from former Soviet bloc countries. Cosmopolitan to its roots, Marseille entered into particularly close relations with North Africa as a result of the French colonial adventure. In the nineteenth century the city grew rich on the spoils of colonialism, both as a port of entry for raw materials from Africa, and as a centre for their industrial processing. It also manufactured goods for export to the colonies. Marseille is still known today for its soap, oil and sugar; and continues to make tiles for export to Algeria. Under the Second Empire, the port city of Algiers became the primary military and administrative centre for France's colonial territories. In the Second World War it housed the headquarters of Allied forces in North Africa, and was for a time the provisional capital of France. During the period from the French capture of the port of Algiers in 1830 to its independence in 1962, Marseille and Algiers evolved virtually into mirror images of one another.

From the time of its first great prosperity, Marseille has been known to the French as *la ville populaire*, 'the working-class city'. After the Second World War it also became called *la ville socialiste*. Marseille never developed the socio-geographic form of most other French cities – with wealth concentrated at the centre and poverty distributed mainly around the peripheries. Marseille is a decentred aggregate of village-like communities. Working-class solidarity provided the political cement that long held together the breccia of culturally heterogeneous populations which make up the city. With the end of colonialism, however, the cement began to crumble. The exodus from Algeria resulting from the war of independence

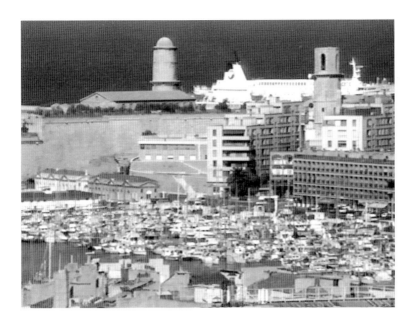

produced a sudden and overwhelmingly large increase of population in Marseille. An estimated 1.5 million 'pieds noirs' – French citizens born in North Africa – came to France at that time, the majority to settle in and around Marseille. As the population of Marseille increased, the city simultaneously suffered huge losses of industry based on materials from, and trade with, the former colonies. Since mid-1970, the rate of unemployment in Marseille has been twice the national average for France. With the decline of industry, the consequent decomposition of the old working-class neighbourhoods undermined working-class culture and the socialist and communist city politics based on it. In the electoral campaigns of 1983 a race-based politics emerged in which 'immigration' became a major issue. Gaston Deferre, socialist mayor of Marseille for 23 years, was defeated. Two years later, in 1985, the first National Front deputy was elected to the Marseille city government.

The built environment of Marseille today is almost entirely a product of Haussmannesque redevelopment during the nineteenth century. The twentieth century added only two monuments of note to the city: the 'transbordeur' bridge, built in 1905 to join the opposing banks of the old port, and Le Corbusier's 'Cité Radieuse', built between 1947 and 1953. Marseille was not to enjoy both monuments at the same time. Its famous 'pont transbordeur' – photographed and filmed by such modernist notables as László Moholy-Nagy and Florence Henri – was partially destroyed by the German army in 1944, and the remains demolished by the French in the following year. The historic area of the port surrounding the bridge had already been practically erased. In January of 1943, two months after the arrival of the German army in Marseille, the Chief of German police informed French authorities that Marseille was 'the cancer of Europe'. He declared that Europe would not live unless Marseille was 'purified', and gave notice that the 'old quarters' were to be 'cleaned of all undesirables' and the buildings destroyed. The area around the old port, especially the tangle of medieval and Renaissance streets known as 'Le Panier', had long been stereotyped with a notoriety comparable to that bestowed on the Casbah of Algiers. On 23 January 1943, the Vieux-Port was surrounded by the German army. On Sunday, 24 January, the French police rounded up the inhabitants of the encircled area. The first convoys of those arrested in an earlier swoop on the city centre were already leaving Marseille for death camps at Buchenwald, Sobibor and Sachsenhausen-Orianenburg. Between 1-17 February, German sappers blew up 1,494 buildings.

In 1993 work began on a vast underground car-park by the old port. An enormous pit was excavated, its cliff-like walls striated with centuries of occupation. Debris from the demolition of 1943 lay close to the uppermost layer. In the deepest layer, workers found the largely intact skeleton of a Phoenician ship.

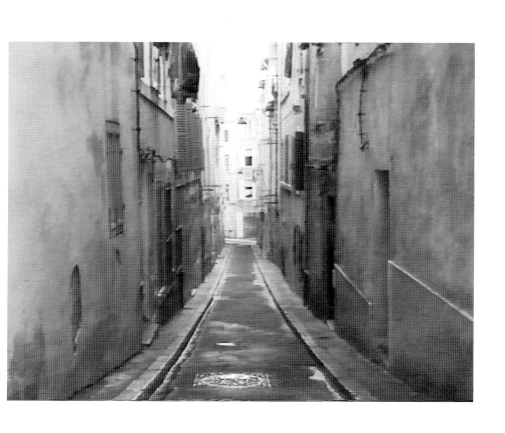

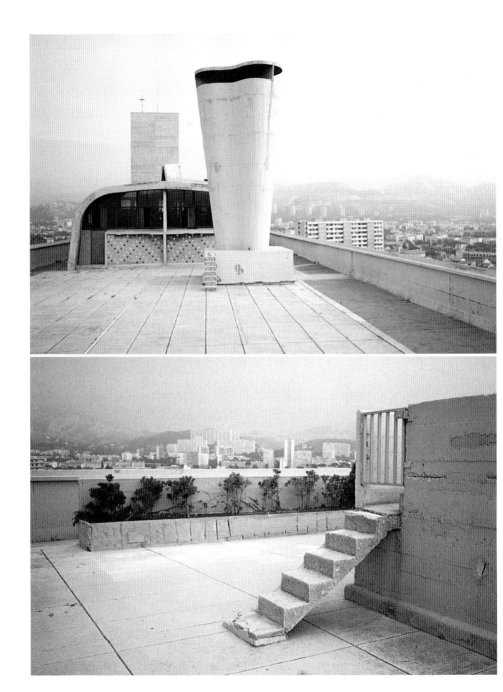

The story begins when a man hires a detective to follow a woman through a city. The man is an old acquaintance of the detective, the woman is the man's wife. What city it is depends on whether we are speaking of the book, or the film. The book is *D'Entre Les Morts*, by Pierre Boileau and Thomas Narcejac. The film is *Vertigo*, by Alfred Hitchcock.

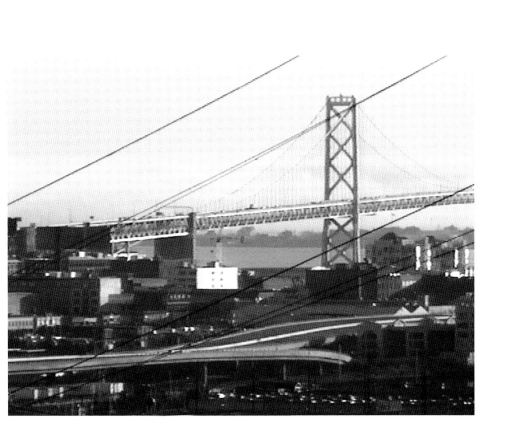

A man hires a detective to follow a woman. The man fears that his wife, Madeleine, will harm herself. Madeleine is obsessed with the history of her great-grandmother. When the great-grandmother was still a young woman, she killed herself. A portrait of her was made shortly before her death. In the film, the detective watches as Madeleine sits contemplating the portrait. In the book, it is the husband who watches. He notices how Madeleine arranges her hair in the same style as her great-grandmother. Everything the detective observes confirms his client's conviction that Madeleine can no longer distinguish between herself and the dead woman. Madeleine is now the age her great-grandmother was when she died. The detective follows Madeleine as she visits places in the city associated with the dead woman. He is there when Madeleine throws herself into the ocean. He saves her life. They fall in love. Unable to escape the grip of the past, she throws herself from a tower and dies. In the book, the authors write: 'She was dead. And he was dead with her.'

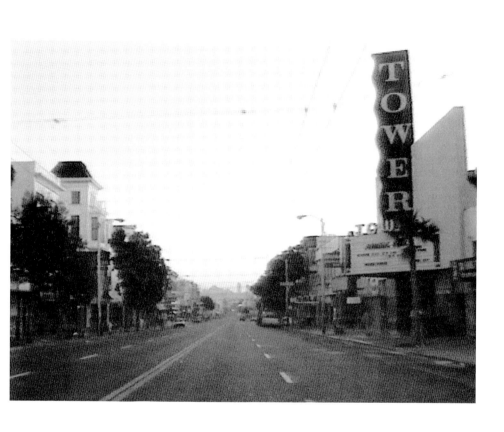

The second part of the story begins when the detective sees, in a city street, a woman who resembles Madeleine. The detective is obsessed by the memory of Madeleine. He follows the woman to a hotel where she lives, and persuades her to have dinner with him. Although the new woman seems physically almost identical to Madeleine, in every other way she is totally different. Where Madeleine was elegant and refined, the detective finds her 'double' to be vulgar. He sets about remaking the woman into an exact replica of Madeleine. He insists that she wear clothing identical to that worn by Madeleine, and that she change the colour and style of her hair to match that of the dead woman. The detective's obsession with a dead past, his determination to resurrect it in a living being, results in the woman's death. The story ends with the detective, again, alone.

In Hitchock's film, *Vertigo*, the story takes place in San Francisco. The first time I visited San Francisco, many years ago, I went looking for the places where the film was shot – places already familiar to me from the film. I knew nothing of the original story other than its title, and the names of the authors. While I was in Marseille, to make a video about the city, I decided I would read the novel on which the film is based. I found that whereas the film is set entirely in San Francisco, the authors of the book had set the story in two different cities – and that their choice of cities reflected the class difference between the two women. The first part of *D'Entre Les Morts*, the story of the affluent Madeleine, takes place in Paris. The second part of the story, the story of Madeleine's working-class double, takes place in Marseille.

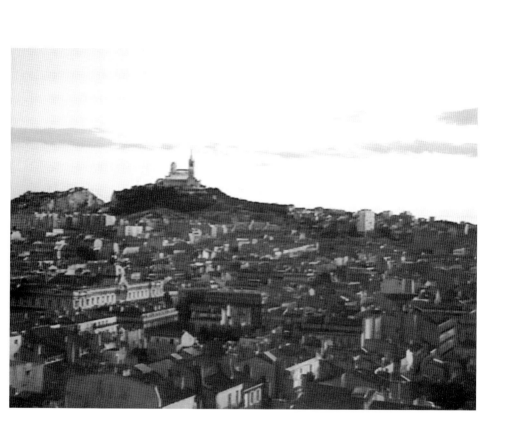

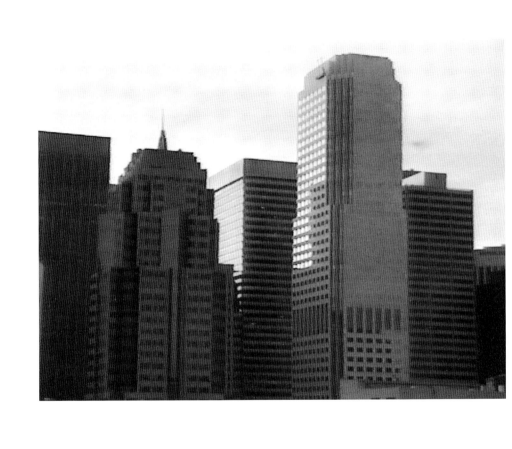

Vertigo, the 1958 Hollywood remake of a French novel, has something in common with *Algiers*, the 1938 Hollywood remake of a French film. Both stories may be read as variations of the Orpheus myth. In *Vertigo*, a detective brings a woman back from a simulated death, only to see her die in reality. In *Algiers*, a woman brings a gangster back from a spiritual death (hiding in the Casbah, he longs for Paris), only to bring about his actual death. The downfall of the WASP detective is brought about by a working girl. The demise of the proletarian gangster is brought about by a rich girl. Both detective and gangster are doomed by their inability to truly live in the present. Through the city, the detective seeks a lost woman. Through a woman, the gangster seeks a lost city.

Incapable of escaping the grip of the past, the inhabitants of Marseille and Algiers still live partly among the rubble of the terrible war for Algerian independence. Subsequent years have seen the shattering of Algiers with the rise of the murderously anti-secular Armed Islamic Group (one of at least three military organizations more or less controlled by the military leadership of the Islamic Salvation Front). France is suffering the rise of the viciously racist National Front. New graffiti on Marseille walls expresses right-wing nostalgia for old acts of terrorism.

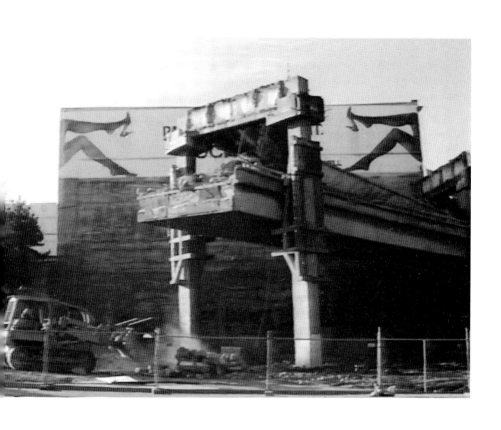

In Marseille, I am invited to lunch at the home of two women. We eat in the kitchen, which contains a huge American refrigerator. Attached to the refrigerator door is a scroll with an inscription formed in Arabic characters. I ask what it means. I am told that it is, quite simply, the Arabic alphabet. The women explain: Christine – pale hair, light skin – was born in colonial Algeria, into a family of the administrative class. Inside and outside the home she spoke French. In keeping with the professional practice of her class she had learned to read, but not speak, Arabic. Dalila – jet hair, dark skin – was born in northern France, into a North African family of workers who had left Algeria after independence. Inside the home she spoke Arabic, outside the home she spoke French. She had not learned to read Arabic, as there had previously seemed no reason to do so. Christine was teaching Dalila to read. Dalila was teaching Christine to speak.

The 'Sunset' residential district of San Francisco was once only sand dunes. In a film of 1921, *White Hands*, these dunes became the deserts of Algeria. A set was built by San Francisco bay to represent the port city of Algiers. The film *Algiers* ends as the dying gangster watches the boat for Paris steam out of the harbour into the open sea. As a child in Sheffield, I imagined that the factories were huge steam ships. The ships have all left Sheffield. But now and then I find them sailing through some cities.

It was dawn when he said:
'Sire, now I have told you about all the cities I know.'
'There is still one of which you never speak.'
Marco Polo bowed his head.
'Venice', said the Kahn.
Marco smiled.
'Every time I describe a city, I say something about Venice.'

Italo Calvino, *Invisible Cities*

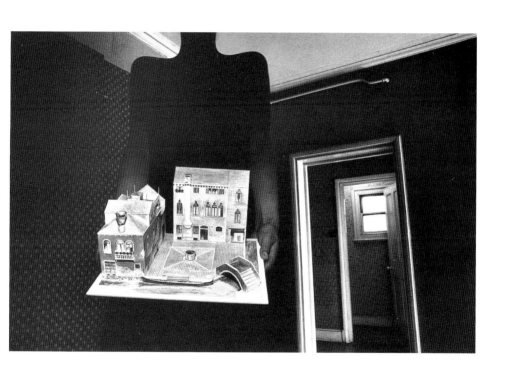

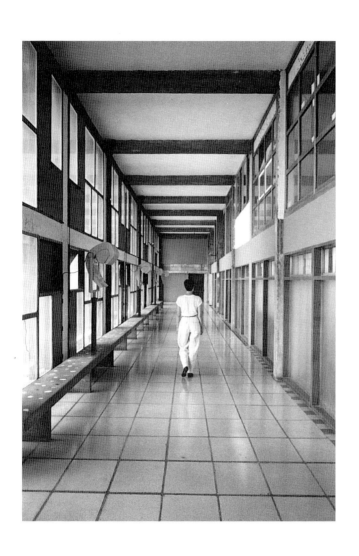

For the woman in the corridor

Images

Unless otherwise indicated, all photographs and video stills are by Victor Burgin.

Acknowledgements

Although I received no direct grant support for the production of this book, the following sources provided much of the work-space and travel time of which it is a by-product:

Faculty research funds and sabbatical leave granted by the University of California, Santa Cruz.
Ville d'Orléans, 1994
Institut Méditerranéen de Recherche et de Création/Ville de Marseille, 1993
Allocation de recherche et de séjour, Ministère de la Culture et de la Communication, 1991
Ville de Blois, 1991
Adelaide Festival of the Arts, 1988
Polish Union of Filmmakers and Photographers/The British Council, 1981
Musée de Grenoble/Ville de Grenoble, France, 1981
Malmö Konsthall/British Council, 1981
Espace Lyonais d'Art Contemporain/Ville de Lyon, France, 1980
Deutscher Akademischer Austauschdienst (DAAD) Fellowship, Berlin, 1978–9
US/UK Bicentennial Arts Exchange Fellowship, 1976–7

The institutional anonymity of this list conceals the identities of the far-flung individuals who have led me to wish that the 'global village' was a reality.

222

Photographic acknowledgements

The publishers wish to express their thanks to the following for supplying photographic material and/or permission to reproduce it: Photo Researchers for *Halifax*, 1936, by Bill Brandt, © Bill Brandt/ Photo Researchers. MCA Publishing for stills from *Vertigo*, 1958, by Alfred Hitchcock, © Universal Pictures, a Division of Universal City Studios, Inc., courtesy of MCA Publishing Rights, a Division of MCA, Inc.